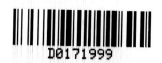

Rock-Art
of the
Southwest

A Visitor's Companion

Liz and Peter Welsh

 WILDERNESS PRESS • BERKELEY

FIRST EDITION October 2000

Photos by Liz and Peter Welsh
Maps by Thomas Brennan
Book and cover design by Larry B. Van Dyke

Library of Congress Card Number 00-063348
ISBN 0-89997-258-6

Manufactured in the United States of America

Published by **Wilderness Press**
1200 5th Street
Berkeley, CA 94710
(800) 443-7227; FAX (510) 558-1696
mail@wildernesspress.com
www.wildernesspress.com
Contact us for a free catalog

Cover photo: **Three River State Park, New Mexico,** © 2000 Welsh

Library of Congress Cataloging-in-Publication Data

Welsh, Liz, 1951–
 Rock-art of the Southwest : a visitor's companion / Liz and Peter Welsh.— 1st ed.
 p. cm.
 Includes bibliographical references and index.
 ISBN 0-89997-258-6
 1. Indians of North America—Southwest, New—Antiquities. 2. Petroglyphs—Southwest,
 New. 3. Rock paintings—Southwest, New. 4. Southwest, New—Antiquities. I. Welsh,
 Peter, 1950– II. Title.

 E78.S7 W39 2000
 709'.01'130979—dc21

 00-063348

Contents

Preface vii

Introduction 1

Encountering Rock-Art 5
 What Is Rock-Art? 7
 How Was Rock-Art Made? 13
 Petroglyphs • Pictographs • Geoglyphs
 What Is Rock Varnish? 25
 Which Rocks Were Used? 27
 Where Is Rock-Art Found? 29
 Enlarging Your View • Rock-Art Settings

Understanding Rock-Art 39
 The Rock-Art Puzzle 41
 Who Made Rock-Art? 43
 Rock-Art Styles 45
 Determining the Age of Rock-Art 57
 Why Was Rock-Art Made? 63

Protecting Rock-Art 79
 Does Rock-Art Need Protection? 81
 Visiting Rock-Art Sites 85
 Visitor Guidelines • Photography • Reporting Vandalism
 Conservators: Specialists in Rock-Art Care 103
 Native Americans' Concerns 105

Selected Southwestern Rock-Art Sites 109

 Arizona **114**

 California **120**

 Colorado **124**

 Nevada **125**

 New Mexico **127**

 Texas **132**

 Utah **134**

Organizations 143

Special Resources 147

Selected Web Sites 151

Illustration Notes 155

Index 161

Preface

AN ENCOUNTER WITH ROCK-ART can stop you in your tracks. Its presence confirms—with startling clarity and intimacy—an exciting truth that is sometimes forgotten: Both in wilderness areas and in the midst of our cities, *people were here before us*. On the very spot where you stand looking at rock-art, someone from a different era and culture once stood creating it.

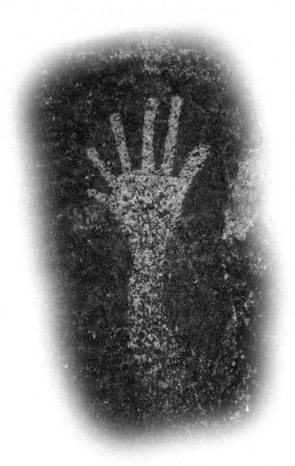

Why were the marks made? For what purposes? Why were they placed in this particular location? What do the designs signify? Who made them, and when? The more you ponder, the clearer it becomes that even the simplest questions surrounding rock-art are surprisingly difficult to answer.

Tens of thousands of petroglyphs and pictographs have been made in many different settings across the Southwest. You might come across them in the backcountry, at a national park, or even in your own neighborhood. At some sites, designs are bold and prominently situated—elsewhere, they are tiny and concealed in hidden places. They may be delicately pecked into dark boulders, painted in dramatic colors on vast cliff walls, or created as giant-sized figures on the ground. Technique is sometimes rough and rudimentary—and sometimes it is the work of a skilled and practiced hand. Imagery may be identifiable—or utterly enigmatic. Rock-art's quantity, variety, and beauty are astonishing.

THIS BOOK is for anyone whose imagination has been captured by these intriguing markings. In jargon-free language, it addresses the questions most frequently asked about Southwestern rock-art. A wide range of basic information is covered, common misconceptions are clarified, controversial interpretations are discussed, and emerging new ideas about rock-art are explained.

Rock-Art of the Southwest: A Visitor's Companion also shows you how to think about rock-art in new ways and gain more from your experience as a site visitor. Practical guidelines for minimum-impact site visits, along with information on how to report vandalism, are included in the discussion of rock-art protection. A directory section points the way to a number of outstanding Southwestern sites, and an annotated resources section lists local and national rock-art organizations, research centers, and a selection of informative Web sites.

Your explorations of rock-art in the Southwest may take you into magnificent canyons, along ancient trails, and into other settings of awe-inspiring beauty. Your experiences and enjoyment will be greatly enriched as you increase your knowledge and understanding of rock-art and of the people who made it. Above all, we hope that heightened awareness and appreciation will motivate you to take an active role in protecting this irreplaceable cultural heritage of the Native American Southwest.

Introduction

ROCK-ART STUDY IN THE SOUTHWEST TODAY is a lively and dynamic field. Exciting avenues of research are being explored, wide-ranging interpretations of evidence are under discussion, and even the subject of exactly *how* to study rock-art stimulates debate.

Although petroglyph and pictograph sites in the Southwest have been investigated throughout the last century for a variety of purposes, it was not until the 1960s and 1970s that systematic research began in earnest. Thus, the field is young, and to better understand the developing state of current knowledge, it is helpful to review the background out of which rock-art study in the Southwest has grown.

Garrick Mallery (whose *Picture-Writing of the American Indians* was published by the Smithsonian Institution in 1893) was one of the field's pioneers. Mallery saw Native American petroglyphs and pictographs as a primitive form of writing. He believed that the study of rock-art could help explain how written language began. Although Mallery's underlying premise that cultures evolve "from barbarism to civilization" is no longer accepted, his rock-art descriptions and the extensive information he collected from regional authorities remain useful data for researchers.

Beginning in about the 1920s, discrete rock-art styles began to be identified in the Southwest. It was recognized that petroglyphs and pictographs at some sites looked very similar to those at other sites, and that rock-art could be classified based on its design elements and the techniques used to make it. The identification of rock-art styles marked the beginning of associating rock-art with particular cultural traditions. Defining and studying styles remains central to Southwestern rock-art research.

By the 1960s and 1970s, rock-art documentation had become the focus of fieldwork efforts. Many rock-art sites were clearly jeopardized by construction projects, vandalism, and other impacts of population growth in the booming Southwest. The development of meticulous site-recording procedures and the refinement of data-collection methods mark this era. The urgency of documentation and preservation work has

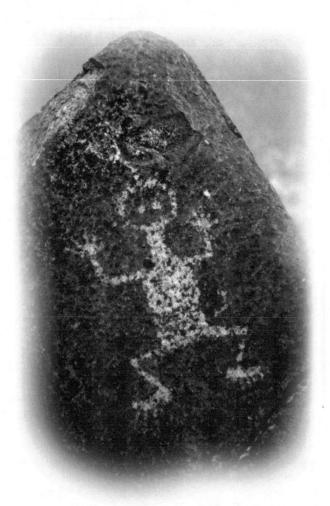

by no means lessened today, and techniques surely will continue to be improved into the future.

The 1980s and 1990s were a period of intensified interest in the expertise of Native Americans. Living experts were consulted, and the ethnographic literature of the late nineteenth and early twentieth century was reread with fresh appreciation. Value was seen not only in what Native Americans know about ancient rock-art from their tribes' oral histories and traditions, but also in the role of rock-art in contemporary Native American culture. The unique knowledge and perspective that

Native American authorities bring to the study of rock-art remains crucial to any comprehensive understanding of the subject.

At the opening of the twenty-first century, issues both old and new define Southwestern rock-art study. Can it be determined with certainty why rock-art was created? What do individual designs signify? Can rock-art be accurately dated? Is the work of individual rock-art makers identifiable? These and other questions will fuel the research and analysis of Southwestern rock-art for years to come.

A STUBBORN PROBLEM has frustrated Southwestern rock-art researchers for decades, however. Despite wide awareness of rock-art—and despite rock-art's ubiquity and remarkable level of preservation—it has resisted easy incorporation into systematic studies of the Southwest's prehistory.

The fact that rock-art is so difficult to date is at the heart of the problem. It is notoriously tricky to determine the age of most rock-art using standard archaeological dating techniques, and the results of most analyses raise as many questions as they answer. To add to the problem, rock-art is rarely part of a site's stratigraphy, the sequential layers of deposits used in modern archaeology to determine sequences of events. Thus, it has been difficult for archaeologists to integrate rock-art into their investigations of particular prehistoric sites, or to connect it with the people who lived in a place at a specific point in time.

ROCK-ART'S "ORPHAN" STATUS explains the emergence of rock-art study as a separate research domain. In some ways, the existence of such a field is a little odd—scholars today rarely single out a particular type of artifact and study its existence in every place, time period, and culture. However, by conceding rock-art's awkward relationship with mainstream archaeology, and by focusing instead on the material itself, rock-art research has thrived.

Maintaining a separate field of rock-art study also increases the potential for certain kinds of insights into this perplexing subject. Some researchers believe that a better understanding of rock-art in the Southwest will emerge from broader study of rock-art worldwide—that compiling and comparing information from many places will stimulate new thinking and help shed light on unclear issues.

Additionally, rock-art researchers in all parts of the world share pressing concerns about the vulnerability of sites. Working together has produced a strong voice for heightening governments' awareness of rock-art's significance, for educating the public about how to minimize their impact on rock-art, and for mobilizing individuals and organizations to record and protect it.

AS YOU EXPLORE SOUTHWESTERN ROCK-ART, remember that there is still a great deal to be learned about Native American petroglyphs, pictographs, and geoglyphs. New information is constantly being gathered, methods for research and analysis are steadily improving, and findings about rock-art from all over the world are being evaluated in relation to Southwestern cultures and prehistoric sites.

Contemporary understanding of rock-art will undoubtedly grow, and ideas about it will surely continue to evolve, but the importance of protecting rock-art is one thing that will never change. This book's **Visitor Guidelines**, pages 86–95, explain how and why to enjoy rock-art sites as an informed and involved advocate for site protection. The many ways in which the rock-art of the Southwest enriches lives will continue only with every individual's concerned participation.

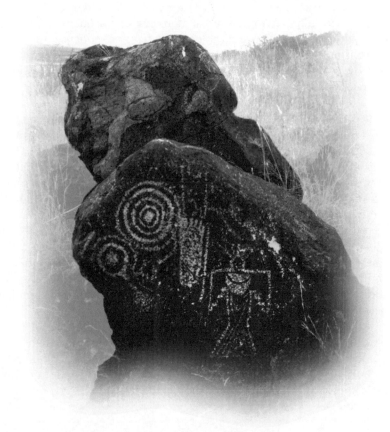

Encountering Rock-Art

What Is Rock-Art?

How Was Rock-Art Made?
Petroglyphs • Pictographs • Geoglyphs

What Is Rock Varnish?

Which Rocks Were Used?

Where Is Rock-Art Found?
Enlarging Your View • Rock-Art Settings

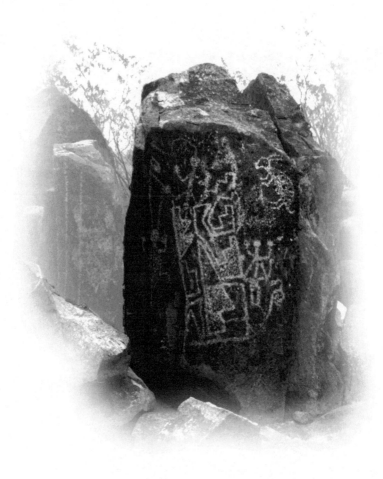

What Is Rock-Art?

ROCK-ART is a term commonly used for the designs and other intentional marks that people have made on natural geological surfaces. It refers to marks made—and left—in situ. Rock-art is not meant to be portable. The marks take many different forms. Figures pecked into boulders and bedrock; paintings on cliff faces and cave walls; designs made by reconfiguring gravel on the ground surface—all of these are rock-art.

Around the globe, rock-art is found on every inhabited continent, and the time span of its production is enormous. Cave paintings in parts of Australia and Europe were created tens of thousands of years ago, and rock-art is still being made today in central Africa, western Australia, and parts of the United States.

In North America, almost all rock-art is Native American. It has been created continent-wide by people of many different cultures and traditions, beginning thousands of years ago and continuing into the present. In the southwestern United States alone, there are tens of thousands of rock-art sites. And every year, a few rock-art sites are rediscovered after many decades—or even centuries—during which no one seems to have been aware of their existence.

"ROCK-ART" is a widely accepted term, but its shortcomings are worth noting. In particular, the word *art* can be misleading. In our culture, art is a form of personal expression—something an artist creates for others to experience. However, there is no evidence from archaeology, ethnography, or cross-cultural studies to suggest that prehistoric Southwestern rock-art involved that kind of individual creative expression or artist-audience relationship.

Still, rock-art has visual qualities that appeal strongly to today's aesthetic sensibilities, and we often respond as if it *were* art in the modern sense. On one hand, this encourages us to accord rock-art an extra measure of respect and protection. On the other hand, it can lead us to evaluate rock-art in terms of contemporary taste and values—significantly reducing our chances of understanding it on its own terms.

Throughout this book, the term *rock-art* is hyphenated, following the example set recently by researchers Paul S. C. Taçon and Christopher Chippindale. This small change from the more usual *rock art* is meant to emphasize that rock-art encompasses something more than—and different from—"art" on "rock."

All in all, use of the word *art* in talking about rock-art subtly puts it into a category where it really does not belong. To avoid misleading implications, many people find the words *petroglyph, pictograph,* and *geoglyph*—terms that are based on how the marks were made—more appropriate.

A PETROGLYPH is a rock-art design that has been made by removing material from a rock's surface. The word was coined by the German scholar Richard Andrée in the late 1800s. *Petro* is from the Greek word for "rock" or "stone," and *glyph* is from the Greek word for "carve" or "engrave." Petroglyphs have also been called by other names, including *glyphs, rock engravings, rock drawings, rock etchings, rock carvings, picture writing, picture rocks, Indian signs,* and *Indian hieroglyphics.* In the United States today, *petroglyph* is the most commonly used term.

To make petroglyphs, tools are used to peck or incise a rock's surface. A design is produced not only by the recessed areas and the texture created by the tools, but also by color contrast—petroglyph designs are almost always lighter than the surrounding unworked rock. This contrast occurs because most rocks chosen for petroglyphs have a dark natural coating known as rock varnish. When that dark surface layer is pecked or scratched away, the lighter-colored interior rock is exposed. (See **Petroglyphs,** page 14, and **What Is Rock Varnish?** page 25.)

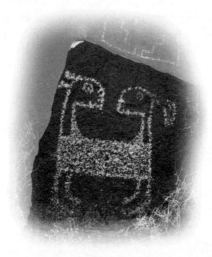

Petroglyphs are the main type of rock-art in the southwestern United States. Tens of thousands of petroglyph sites exist. Petroglyphs have been made on all kinds of rocks, from melon-size cobbles to massive cliff walls, and petroglyph sites range from single, isolated marks to dense concentrations covering hundreds of square feet. Painted rock-art is occasionally found along with petroglyphs, and some rock-art designs combine painting and petroglyph techniques.

A PICTOGRAPH is a rock-art design that has been made by applying colors to a rock surface. *Picto* is from the Latin word for "paint," and *graph* is from the Greek (and Latin) word for "write." Pictographs have also been called *cave paintings, cliff paintings, rock paintings,* and *picture rocks.* In the past, the term *pictograph* was sometimes used to refer to all rock-art. Today, it most often means colored marks and designs drawn or painted on a rock surface.

Paint was used to create many pictographs, although some designs were made by drawing with media such as charcoal sticks and pieces of soft mineral. Since the most common colors used for Native American pictographs are black and shades of red, the work was usually done on light-colored rock. Pictograph and petroglyph techniques were sometimes used together in rock-art. (See **Pictographs**, page 18.)

The paints and other colorants used for pictographs are not weatherproof, and the ancient pictographs that have survived to the present are in places sheltered from rain, snow, and scouring winds—such as in caves, in rock shelters, and on vertical surfaces beneath overhangs.

Overall, pictographs are far less common than petroglyphs in the American Southwest, although in a few regions—in west Texas, and in the Tulare and Santa Barbara areas of California, for example—they are the predominant form of rock-art.

A GEOGLYPH is a rock-art design made on the ground surface. *Geo* is from the Greek word for "earth," and *glyph* is the Greek word for "carve" or "engrave." Particular kinds of geoglyphs include intaglios (designs made by removing stones or portions of the ground surface), petroforms or rock alignments (designs made by rearranging stones), and gravel geoglyphs (designs made by shaping or modifying gravel-covered areas).

The term *geoglyph* lumps together a number of different forms of rock-art, none of which seem to have been very common or widespread. In addition to all having been made on the ground surface, they share another distinctive feature: their large size. Geoglyphs are sometimes so large that the work can barely be perceived while standing next to it. Geoglyphs are not generally found in direct association with pictograph or petroglyph sites.

In the American Southwest, most geoglyphs have been found on desert mesas in southern California and southwestern Arizona, near the Colorado River drainage. (See **Geoglyphs**, page 22.)

OTHER ROCK FEATURES MAY ALSO BE PRESENT AT ROCK-ART SITES. Of particular interest are those that appear to be related to the petroglyphs or pictographs at the site:

◎ Grinding slicks (smoothed areas) may be the result of rubbing stones together to produce a sound or to pulverize food, medicine, or paint.

◎ Boulder arrangements may create observatories—some seem to be for monitoring the sun or other celestial bodies; others allow sighting from one locale to another.

◎ Paint or clay blobs may dot the ceiling or walls of a cave, seeming to have been thrown.

◎ Cupules (small hemispherical pits) may have been created, sometimes even on vertical surfaces, which suggests that they were not intended to hold anything.

◎ Spark-producing rocks may have been struck to give off flashes of light.

◎ Audio effects, such as echoes, may result from the configuration of the site.

These and other features—some prominent, others subtle; some common, others rare—hint at the complexity of rock-art sites. Quite clearly, much more is involved than the pecked or painted designs that we notice first!

How Was Rock-Art Made?

IMAGINING THE SCENE while rock-art was being made is an intriguing exercise. Who actually made the rock-art—women? men? children? Was it created by people working together or by an individual working alone? How long did it take to make a petroglyph or to paint a pictograph? Was work completed in a single session or developed and augmented over a period of time? How was the site chosen? Were ladders or ropes used to reach high or remote places? Was the work done privately, or was it carried out with others watching and perhaps advising? Was it made in the midst of another activity, such as a ceremony? Was there a particular time of day or a certain time of year in which rock-art making took place? How were designs decided upon? Were concepts sketched or roughed-out before work began? What happened once the rock-art was finished—was it exhibited or in some way presented or announced?

These questions—and all the others that flood our minds—remind us that where we stand looking at rock-art today, other people once stood creating it.

In today's world of record-keeping—photography, videotaping, interviews, and other kinds of eyewitness reports—it is frustrating to have no documentation or other first-hand information to answer most of these questions about the making of rock-art. We are accustomed to immediate, authoritative answers, but in this case, the necessary information simply is not available. For studying rock-art of the Southwest, it is helpful to cultivate a high tolerance for uncertainty, ambiguity—and even contradictions.

Despite the many things that are not known, some things about the making of rock-art can be determined by a direct study of the work that has survived today.

Petroglyphs

SELECTIVE REMOVAL OF A ROCK'S SURFACE is the essence of making a pet-roglyph. Rock can be removed by *percussion* or by *abrasion*.

Color contrast is also part of petroglyph-making. Petroglyph designs are visible partly because they are at a different level than the surrounding rock, but also because removal of the rock surface usually breaks through a natural dark layer of rock varnish to reveal lighter colored material below (see **What Is Rock Varnish?** page 25). Similarly, some petroglyphs are made on soot-blackened surfaces (such as in caves where fires have burned), or in places where paint has been applied to a rock wall (such as in the making of a pictograph). Adding to the dark-light contrast, petroglyph-making tools often bruise or shatter crystals in the rock, which makes the worked area even whiter and lighter in appearance. Thus, along with being "recessed," petroglyph designs usually have a lighter color than the adjacent unworked rock.

The depth of petroglyphs varies tremendously. In some cases, just enough rock surface has been removed for the marks to be visible. In other cases, the marks have been made deep in the rock. Occasionally, a petroglyph varies in its depth, with certain parts contoured or sculpted, as in bas-relief.

PERCUSSION and **PECKING** are names used for a petroglyph-making technique in which a tool is struck against the rock's surface. Each time the rock is impacted, a chip or spall is detached, leaving a small crater, sometimes called a dint. Many overlapping dints are made to create a petroglyph by this means. Percussion sometimes results in large peck marks, in which case the petroglyph may have a coarse-looking quality and an uneven edge. Percussion can also remove very small bits of rock to create a finely detailed design. The size of the peck marks depends on the texture of the rock, the precision of the tools used—and, of course, the intentions of the person doing the work.

Based on how the tools were employed, two methods for making pecked petroglyphs have been identified: *direct percussion* and *indirect percussion*. Although it is easy to tell whether a petroglyph was made by percussion—the dints or peck marks leave a very characteristic texture of dimples—it can be difficult to know for sure whether a direct or indirect technique was used in a specific instance.

Direct percussion means striking a tool directly against a rock surface. In the Southwest, the tool used for this method would have been a hand-held hammerstone with a pointed end. These hammerstones, made from hard materials such as quartzite, chert, greenstone, and volcanic rock, are often found where petroglyph makers left them at rock-art sites.

Indirect percussion means that one tool (a punch or chisel) is positioned against the rock surface, while a second tool (a hammer) is used to strike its opposite end. Before metal implements became available, the tool in direct contact with the rock probably would have been a pointed antler, bone, or stone tool, while the tool used to strike it would have been a hammerstone. Indirect percussion permits more precise control of the size and location of pecking than direct percussion. It also sometimes results in slightly linear individual marks if the tool in contact with the rock is not pointed, or if it slips slightly with each blow.

In the southwestern United States, petroglyphs made by percussion methods are, by far, the most frequently seen rock-art. Pecking is used to create lines, solid areas, and even speckled patterns. Sometimes, dense pecking is used along with sparse pecking in a design to create areas with different degrees of lightness. Pecking may be used to create

very deep marks or marks that are quite shallow. Designs often make use of a rock's contour, cracks, or inclusions. Contoured, sculpted pecking was occasionally used to give greater dimensionality to one part of a petroglyph.

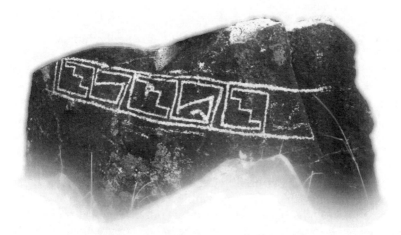

ABRASION, SCRAPING, and **GRINDING** are other petroglyph-making techniques. In this method, the rock's surface is scratched or scraped to create designs. The resulting marks range from thinly incised lines to deeply ground-out grooves.

Petroglyphs made by abrasion are easily distinguished from pecked petroglyphs. The marks are linear—either inscribed with a pointed tool or more deeply engraved by rubbing or grinding a tool back and forth along a line. In cross section, these marks are likely to be more V-shaped than the U-shaped cross section of marks that result from pecking.

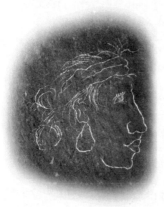

A number of different tools must have been used to make petroglyphs of this type. Sharp-edged flaked-stone tools made from hard materials like chert, quartzite, obsidian, and fine-grained volcanic rocks would have been used to execute fine-lined designs. Pointed tools made from bone or antler may have been used on softer rock like tuff (a fused volcanic ash) or sandstone. Deep grooves would have involved repeatedly rubbing or grinding a tool within a line. Percussion and abrasion techniques were also sometimes combined.

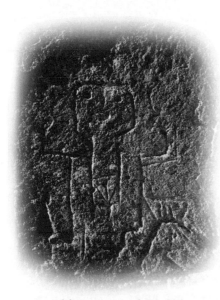

As is true for petroglyphs made by percussion, petroglyphs made by abrasion were often created on surfaces darkened by natural rock coatings, soot, or paint. In some other cases, however, a color contrast seems not to have been important to the petroglyph maker. Particularly in soft rocks like tuff, petroglyphs were scratched or ground into surfaces that did not have a dark exterior layer. Petroglyphs made by abrasion are most common in softer rocks like sandstone, tuff, and limestone; petroglyphs on harder igneous rocks like basalt were rarely made by this method.

In addition to making linear marks on rock, abrasion techniques were used for smoothing rock surfaces in preparation for other rock-art work, particularly pictographs. For this, a rock surface was rubbed or ground smooth with a grinding stone. Sometimes these smoothed areas are visible in rock-art panels because their flatness contrasts with the surrounding rock.

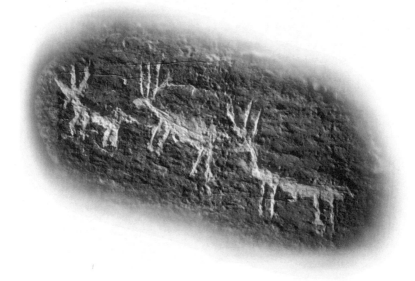

Pictographs

THE APPLICATION OF COLOR TO A ROCK'S SURFACE is the essence of making
a pictograph.

In contrast to petroglyphs—which most often were made on dark-
colored rocks—pictographs in the Southwest were usually made on
light-colored rocks, which enhanced the visibility of the designs. The
rock surface was used either in its natural condition or after it had been
prepared by smoothing it with a grinding stone. Both dry media and
liquid paints were used in the creation of pictographs, sometimes both
together. It is also common for petroglyph techniques to be combined
with pictograph techniques—occasionally, designs were scratched
through a paint layer to the rock surface below, or parts of the rock-art
design were made separately by pecking or scraping techniques.

It is fascinating to look for clues to the methods used to make pic-
tographs, but often the rock-art is too weathered and deteriorated for a
determination to be made. At many sites, the pictographs have been
exposed—sometimes for millennia—to rain and snow, moisture seep-
age, blowing sand and dust, intense sunlight, and other forces that alter
their appearance. What remains today may be little more than stains on
the rock. In some places, however, pictographs are well preserved, and
from these it has been possible to study techniques and materials.

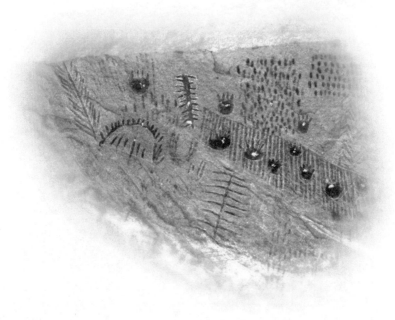

Dry media for drawing—such as charcoal sticks, dried "crayons" of prepared pigments, and lumps of colored minerals—were drawn or rubbed on the rock surface like chalk or a pencil. In most cases, these were used to draw in a linear fashion, but they also could create solid areas of color.

Liquid media—paint—was applied by many methods. It was spread with a brush made from plant fiber or animal hair, or stroked on with an applicator stick. Paint was daubed or spread with fingers. It was also sprayed or spattered from the mouth or through a blowing tube. Stencils were used to block paint in some areas while other areas received color. Direct prints—particularly those made by painted hands pressed against the rock surface—appear in many places. Sometimes the palm of the hand was given an overall coating of paint; other times it was painted with stripes or spiral designs. In many places, pictographs received multiple layers of paint, with considerable time elapsing between some painting episodes.

Colorants used for pictograph designs seem to have been mineral-based pigments and charcoal—not plant-based colorants. However, there is no way to know for sure whether the vivid colors from fruits and other plant parts were used in rock-art. The reason is simple: plant-based colorants are short-lived. The energy in sunlight fuels a chemical change that causes them to fade, and ultimately, they completely lose their hue. Thus, if plant-based colors were used in ancient rock-art, they have not survived for us to see today.

Mineral-based paint for pictographs is typically composed of three parts: *colorant* (the pigment that gives the paint its color); *binder* (a substance that holds the pigment particles together after the paint dries); and *vehicle* (a component, like water, that makes the paint liquid).

Pigments were prepared by pulverizing selected minerals on a grinding slab or by crushing them in a mortar and pestle. Extenders—filler material added to "stretch" a hard-to-acquire colorant, or to make it more opaque—may have been added. Sometimes pulverized pigment was dampened and shaped into cakes, which were dried, wrapped, and stored for later use. Crayons of ground pigment prepared in this way were sometimes used for drawing pictographs. In other cases, the material was reground and mixed with binder and vehicle to make paint. Pigments were, of course, used for more than rock-art—many Native American groups in the Southwest used pigments for body paint and to color textiles, hides, wooden objects, and pottery, among other things.

Relatively little scientific testing has been conducted to analyze paints and other media used in Southwestern pictographs. Thus, much of what is said about this subject is conjecture—based on familiarity with common mineral colors, awareness of what most likely would have been available in various regions, and information provided by knowledgeable Native Americans.

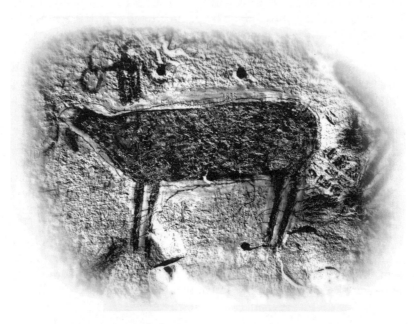

PIGMENTS in pictographs have been identified as follows:

◎ red, reddish-brown, and reddish-orange
 hematite (a reddish-orange mineral, one of the several forms
 of iron oxide), sometimes heated to intensify color
 red ochre; earth or clay tinted by red iron oxides
 cinnabar or vermilion (mercuric sulfide)

◎ yellow
 limonite (a yellow mineral, one of the several forms of iron
 oxide)
 yellow ochre; earth or clay tinted by yellow iron oxides

◎ orange
 red and yellow colorants mixed together, or found together

◎ black
 charcoal, including burned seeds and burned wood
 burned graphite (a mineral form of carbon)
 manganese oxide
 black-colored earth

◎ white
 kaolin and other white clays
 gypsum
 limestone and other forms of calcium carbonate
 talc
 diatomaceous earth
 silica
 white ash from wood fires
 bird droppings
 solidified volcanic ash (tuff)

◎ green
 serpentine (green-colored forms)
 malachite, a copper carbonate mineral
 other copper-rich rocks

◎ blue
 serpentine (bluish-colored forms)
 azurite, a copper carbonate mineral
 charcoal mixed with white minerals

◎ blue-green
 ground turquoise
 malachite, a copper carbonate mineral

◎ pastels of various colors
 clays tinted by mineral inclusions

BINDERS used in pictograph paint in the Southwest are believed to have included:

◎ resin, sap, or gum from plants

◎ oil from oil-rich seeds

◎ fat, grease, or oil from animals

◎ blood

◎ egg white

VEHICLES used to make paint more liquid most likely included:

◎ water

◎ saliva

◎ urine

Geoglyphs

INTENTIONAL ALTERATION OF THE NATURAL GROUND SURFACE is the essence of making a geoglyph. Because the term "geoglyph" is truly a catchall category—and because geoglyphs themselves are relatively uncommon—it is necessary to consider most geoglyphs individually to understand how they were created. Even so, a few generalities may be helpful to point the way.

INTAGLIO—one of the techniques used—involved creating designs by the selective removal of stones and gravel from the ground surface. The word *intaglio* comes from Italian and Latin terms for "engrave" or "cut." Dark-colored rocks lying on the ground were cleared away (or sometimes, simply overturned) to expose lighter-colored ground surface or rock surface below. Thus—like petroglyphs—intaglio designs were created by color contrast, as well as by the recessed areas that result from removing surface material. It is not known what kinds of tools were used in this process (if any), how the designs were planned and laid out on the ground surface, or whether one or many people were involved in the making of huge intaglio designs, some of which measure upwards of 150 feet in length.

ROCK ALIGNMENTS, sometimes called "petroforms," involved gathering and rearranging boulders and stones into straight or curving rows—sometimes hundreds of feet long. Rocks were also arranged to outline an area, or to connect features such as piles of rocks. In contrast to intaglios, these geoglyphs were made by the concentration of rocks, not by their removal.

OTHER GEOGLYPHS were made by scraping or raking the ground surface into patterns and terraces. Dancers systematically trampling the ground surface in circles are said to have made still others.

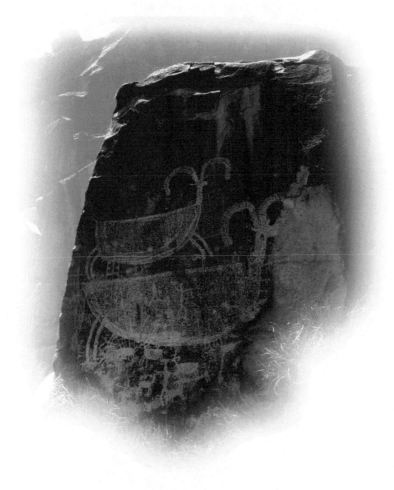

What Is Rock Varnish?

ROCK VARNISH or **DESERT VARNISH** is a glossy black, brown, or orangish-brown layer on the surface of many rocks—on boulders, outcrops, cliff faces, and even desert gravels. Rock varnish is commonly associated with arid regions, but in actuality, it occurs worldwide in many environments. It is of great interest in rock-art study because the majority of petroglyphs (and intaglio geoglyphs, too) use geological surfaces darkened by rock varnish.

Knowledge about rock varnish is also essential for understanding several of the techniques that are used to determine the age of rock-art, and for appreciating important issues in rock-art preservation.

AN EXPLANATION FOR THE FORMATION OF ROCK VARNISH eluded scientists for many decades, but the process is now better understood. Contrary to what was long assumed, rock varnish does not result from weathering of the underlying rock, or from a chemical change on its surface. It is, instead, an accretion—a thin overlying layer, usually less than half a millimeter thick, composed of mineral particles that have been transported from elsewhere, deposited on the rock surface, and cemented in place.

How does this process occur? Colonies of bacteria that live on rock surfaces secrete enzymes that concentrate manganese and iron oxides from the environment. Meanwhile, tiny particles of clay minerals—produced in the decomposition of soils (and various other lithic materials)—are carried by water or air and deposited on the rock. Rock varnish is formed gradually, over centuries, as the miniscule "bricks" of clay-mineral particles are "mortared" together by the iron and manganese oxides and attached to the rock surface.

A typical rock varnish composition is 60 percent clay minerals and 20–30 percent manganese oxide and/or iron oxide, with the remaining 10–20 percent consisting of some combination of more than 30 other minor constituents, such as copper and zinc oxides. The color of rock varnish depends on the relative proportions of manganese oxide and iron oxide: varnish that is black or metallic gray contains predominantly manganese oxide; varnish that is orangish contains predominantly iron oxide.

The process of rock-varnish formation is gradual and ongoing. Particles of clay minerals are constantly deposited, and the bacteria continually provide concentrated manganese and iron oxides. In some places, rock-varnish formation on fresh rock surfaces becomes visible in as little as 50 years. Elsewhere, it takes centuries. In the Southwest, a rule of thumb has been that rock varnish becomes perceptible after about 100 years.

Surface effects and coatings other than rock varnish also exist. Weathering rinds, for example, are the result of changes to the rock's surface from exposure to the elements. Other surface crusts form when soluble material leaches out from the interior or from other rocks nearby. Some dark coatings are from lichens. Rock varnish may form in the midst of these other surface changes and accretions.

ROCK VARNISH CAN HELP DATE PETROGLYPHS. Typically, when a petroglyph is made, varnish that accumulated on a rock surface over hundreds or thousands of years is pecked or scratched away to create the design, exposing fresh rock. But it doesn't stay "fresh" forever. The process of rock-varnish formation continues—adding more to the old rock varnish adjacent to the petroglyph, and also beginning on the newly exposed rock. Recognizing the ongoing, cumulative nature of this process is central to understanding all of the dating methods that involve rock varnish.

The most common use of rock varnish for age estimation is to make a visual comparison of the darkness of petroglyph marks or designs. At any particular site, darker petroglyphs are inferred to be older because they have had time to accumulate a more extensive coating of rock varnish.

Another dating method compares the chemical composition of the rock varnish on top of petroglyphs at various parts of a site. Rock-varnish composition changes over time in a predictable way because weathering leaches out certain elements more quickly than others. The relative ages of varnish on different petroglyphs can be determined using this information—and based on that, the relative ages of the rock-art can be inferred. (See also **Determining the Age of Rock-Art,** page 57.)

ALTHOUGH ROCK-ART MAY APPEAR TOUGH AND DURABLE, it is actually quite susceptible to damage. The thinness and softness of rock varnish contributes to this vulnerability. Rock-art sites are damaged by impact to the rock varnish, whether gradually (as the result of foot traffic and repeated touching) or dramatically (due to injury from tools or vandalism).

Which Rocks Were Used?

ROCK TYPE does not seem to have been the basis for choosing where rock-art was made in the Southwest. Petroglyphs and pictographs are found on all of the region's most common lithic materials—sandstone, limestone, basalt, andesite, tuff, and granite, among others—and there is no correlation between geological classification and the style or subject matter of the rock-art.

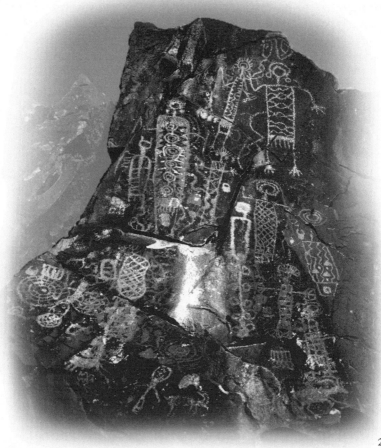

THE LOCATION of the rocks, on the other hand, was clearly a key factor. Rock-art was created at locations seen as significant and important— and the recognition of a place as significant almost certainly preceded the making of rock-art there. There is no reason to believe that rock-art makers searched the countryside for suitable "canvases" on which to produce their "artwork."

Within a locale where rock-art was to be made, surface color was an important factor in the selection of particular rocks. For petroglyphs, a rock with a dark coating of varnish was almost always chosen, as the strong color contrast between the outer layer of varnish and the light-colored inner rock enhanced the visibility of the designs. For pictographs, light-colored rock was most often used, which allowed the colored designs to stand out clearly.

Flat and smooth surfaces also seem to have been preferred—though not required. Pictographs are generally painted on smooth, naturally flat expanses, which sometimes were smoothed even further before the application of paint. Petroglyph makers, too, favored rocks that weren't extremely rough and bumpy—although exceptions are easy to find.

Where Is Rock-Art Found?

Enlarging Your View

ROCK-ART APPEARS IN A VERY WIDE RANGE OF SETTINGS, but these locations were certainly not chosen arbitrarily. Researchers believe that most rock-art was made at special places of cultural or spiritual importance. Today, we consider these places important and significant because of the petroglyphs or pictographs that are there. In the past, however, recognition of the importance of these locations most likely *preceded* the making of rock-art. The rock-art was probably made *because of* the site's special nature—perhaps as part of some activity associated with its importance. Thus, an underlying significance seems to define rock-art sites—and one clue we have to a place's value for past peoples is the existence of the rock-art.

There really is no "best" way to approach an understanding of the places where petroglyphs and pictographs were made. However, whatever your perspective, your appreciation of rock-art sites will be powerfully enriched by enlarging your view—literally.

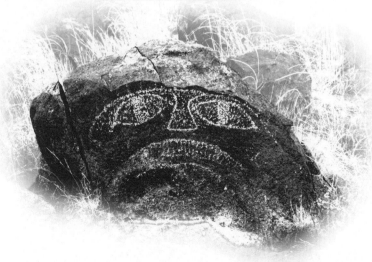

RESIST THE TENDENCY TO LOOK AT ROCK-ART AS PICTURES on a gallery wall—images positioned against a neutral and irrelevant backdrop. An essential step toward gaining deeper enjoyment and understanding of rock-art is to look carefully and thoughtfully at its site and surroundings.

For Southwestern rock-art, the setting may be significant on both a large and a small scale. It may include the particular surface on which a design or mark was made, the rocks and landforms that constitute the site, as well everything in the surrounding landscape. Careful observations will take you beyond "pictures" to reveal the rock-art's complex and fascinating relationship to the surrounding area.

UP CLOSE

- ◎ Has the shape of the rock been incorporated into the rock-art design?

- ◎ Do marks wrap around the rock or make use of more than one surface?

- ◎ Have the rock's irregularities—its pits, veins, inclusions, cracks, ridges, or protrusions—been used in the designs?

- ◎ Have several markings been made on a single surface? If so, how do they interrelate? Do designs overlap? Are design elements repeated?

- ◎ Have designs been reworked? Are there indications of older and fresher marks together? Have some images been covered over or obliterated?

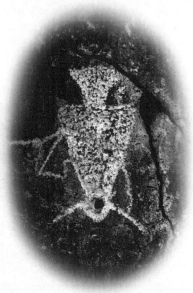

- ◎ How do techniques compare? Do different designs seem to have been made by the same maker using the same materials or tools?

- ◎ Do surrounding rocks have designs or marks? Are they similar to, or different from, neighboring marks?

◎ Are other cultural markings evident on the rock, such as grinding slicks, linear grooves, or cupules (hemispherical dimples, single or in groups)?

◎ At a pictograph site, can you see indications of lost or faded colors? Sometimes markings made with petroglyph techniques (pecking or abrading) hint at the location of details whose colors have become less visible.

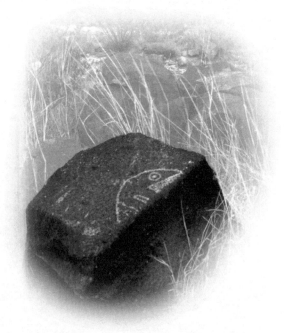

THE SITE SETTING

◎ What is the nature of the site area? An escarpment of tumbled rock? A sheer cliff wall? An isolated boulder? Bedrock?

◎ Does anything distinguish the site setting from the surroundings? Large or prominent rocks? Color seams? Unusual formations?

◎ Are there indications that rocks containing rock-art have moved over time? Upside-down images? Broken sections?

◎ What is the extent of the rock-art in the site area? Is there only an isolated mark? Are numerous markings clustered in one spot? Is the rock-art distributed over an extensive area?

- ◎ Does the site have a particular shape or position? An alcove of rocks? The uppermost boulders on the hill? The widest part of a cliff face? A flat panel next to a stream?

- ◎ Is the site private and concealed, or is it prominent and visible?

- ◎ What cardinal direction does the rock-art face?

- ◎ Are there other indications of human activity nearby, such as grinding slabs or architecture?

- ◎ Are there echoes or sound-altering effects that can be detected?

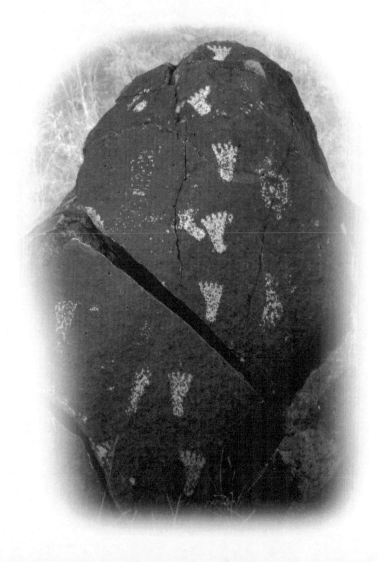

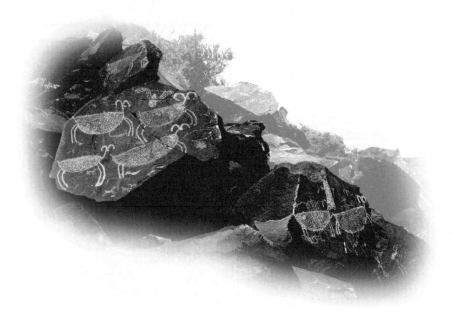

THE WIDER LANDSCAPE

◎ From the site, what prominent or notable geographic features can be seen? Hilltops or mountain tops? A valley? The eastern horizon?

◎ From what places in the surrounding area can the site be seen?

◎ How might the site have been approached? What probably would have been seen first?

◎ Are trails or passes nearby?

◎ Is a source of water nearby?

◎ Are other rock-art sites present in the region?

◎ Are other sites such as habitations, stone quarries, or food-processing sites nearby?

Rock-Art Settings

THE SETTINGS of thousands of Southwestern rock-art sites have been recorded and studied. Rock-art is found high on mountains, alongside streams and springs, in desert valleys, on rocky hillsides, on cliff faces, and in caves—there is truly no geographic setting where rock-art is not found.

SEVERAL TRENDS ARE APPARENT in analyzing site locations, many of which are discussed below. As you visit sites, remember that some aspects of the setting may have changed during the hundreds or even thousands of years since the rock-art was made. Drainage and vegetation patterns are now different in some places, and features like fields and houses may have disappeared from view. Some key information may be available only if archaeological research has been conducted.

Remember, too, that the range of settings reflects the fact that rock-art undoubtedly existed for a variety of different reasons—differences that remind us of the many cultures and lifeways of the Southwest, and the range of activities that took place within each group.

MYSTICAL EXPLANATIONS may underlie the choice of a rock-art site. Some petroglyphs and pictographs are associated with places "revealed" as sacred or holy, or places where people had spiritual or religious experiences. Many rock-art sites are still regarded as sacred places by present-day Native Americans.

WATER is near many rock-art sites. Springs, streams, and seeps—and other water sources that tend to continue flowing when other sources are dry—are commonly associated with rock-art. In the arid Southwest, modern rock-art visitors sometimes think that petroglyphs situated near water are "signs" informing people of its proximity. This is unlikely, however. Native Americans in the pre-horse and pre-motor-vehicle era had intimate knowledge of the territory in which they lived, and they would not have needed written directions pointing them to sources of water.

HABITATION AREAS are *not*—perhaps surprisingly—strongly associated with rock-art sites. Signs of activities like stone-working may be present, and litter such as pottery sherds may be nearby, but a great deal of rock-art seems to have been located some distance away from the places people actually lived. Sometimes rock-art does occur within and around

residential areas, but many rock-art sites lack indications of human habitation in the immediate locale.

HUNTING LOCALES may have rock-art nearby. In some places, rock-art is associated with settings that were especially well suited for stalking and ambushing large game animals like deer and pronghorns.

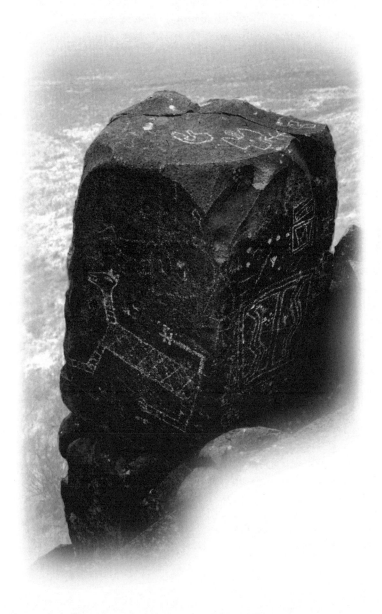

IMPORTANT RESOURCES may be associated with sites. Rock-art has been found in close proximity to sources of wild food plants. Sites have also been found near quarries where special kinds of rock were collected. It seems likely that the importance of these resources was a factor in rock-art having been made there.

AN EAST-FACING ORIENTATION has been noted at many rock-art sites. From an east-facing site, an individual might keep track of the rising sun's changing position on the horizon, or perhaps observe the sunlight's interactions with features of the site.

TRAILS are associated with some rock-art sites. In some cases, the trails are routes through canyons or passes. In other cases, they are straight, cleared paths that lead directly up a slope—paths with no switchbacks, which makes them hard to climb. Researchers think it is unlikely that these were for ordinary travel; they may have been used in strenuous activities that were a part of certain rituals.

PROPERTY may have rock-art associated with it, such as land or food resources that a particular group or clan had the right to control. Ethnographic literature indicates that use of rock-art to mark property has continued into modern times.

CAVES AND ROCK SHELTERS are places where pictographs are often found. Painted rock-art made in more exposed locales would not have lasted long in intense sunlight, dust storms, rain, and snow. Some rock shelters and rock walls with protective overhangs are very open and visible; other caves and shelters are hidden from view. The ways these different sheltered sites functioned—and what importance they held for the rock-art makers—probably varied greatly.

HIDDEN AREAS sometimes seem to be places chosen for rock-art. Some of these settings undoubtedly represent locales of very private activities that were concealed from general view.

ISOLATED HILLS AND POINTS—prominent focal points on the landscape—sometimes have rock-art sites. These rises and promontories might have been appreciated for the broad view they allowed of the surrounding area, or the wide visibility they had beyond the site. Interestingly, however, rock-art is not usually found on the highest peaks or in the most inaccessible places.

DRAMATIC SURROUNDINGS seem to be a characteristic of many Southwestern rock-art sites—a stony prominence surrounded by a forking river, a vast vertical cliff face in a narrow canyon, the "entryway" through a mountain pass. The awe-inspiring grandeur of these locales may have been part of what made them special in the past, as today.

AUDIO EFFECTS are noticeable at some rock-art sites. For instance, sound may resonate in unusual ways that seem to amplify it, confuse the point of origin, or create an echo. At such sites, it seems likely that the sound distortions are part of what made the site important to the rock-art makers.

PREVIOUS ROCK-ART seems to have made some locales significant to later peoples. It is difficult to know whether such sites had inherent importance that transcended time, or whether the presence of earlier rock-art came to define the significance.

In some settings, rock-art has been created in a series of episodes spanning thousands of years. It is striking how common it is for designs at these sites to be superimposed, sometimes apparently "interacting" with the earlier rock-art. Some rock-art appears to have been very deliberately covered over by later work, and there even are instances in which older rock-art appears to have been intentionally obliterated or defaced.

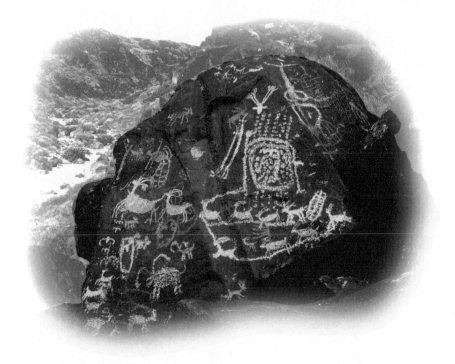

Understanding Rock-Art

The Rock-Art Puzzle

Who Made Rock-Art?

Rock-Art Styles

Determining the Age of Rock-Art

Why Was Rock-Art Made?

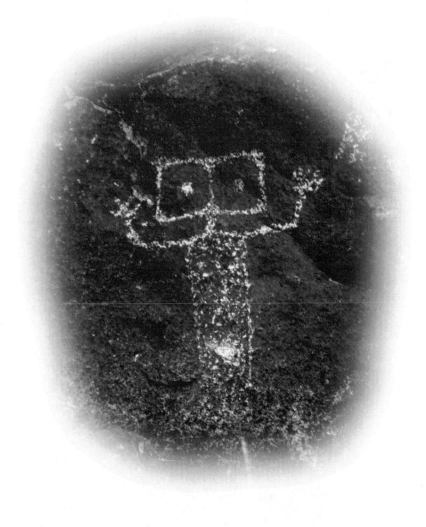

The Rock-Art Puzzle

ARTIFACTS FROM OTHER CULTURES AND EARLIER TIMES seem to automatically prompt comparisons with the corresponding items in *our* world. When we look at prehistoric pit-houses or adobe room-blocks, we relate them to the homes and apartments of today. The handmade stone tools of early Native Americans are contrasted with modern metal implements. Yucca-fiber sandals bring to mind Tevas and Birkenstocks.

In the same way, when we see Southwestern rock-art, we often try to pinpoint something it resembles from contemporary life—some familiar activity or object that we can liken it to.

Graffiti or doodles may be the first associations that come to mind at a rock-art site. After all, like graffiti on an urban building or freeway overpass, rock-art can be pictured as an ancient version of "tagging." Similarly, seen through modern eyes, some rock-art designs resemble the casual patterns of idle doodles.

It soon becomes obvious, however, that these parallels are entirely superficial. Rock-art offers powerful clues that it was both meaningful and important to those who made it. The notable settings in which it was created, the care with which designs were planned and executed, and the long-standing Native American view of rock-art sites as sacred places all argue against rock-art being trivial or insignificant.

Moreover, as we make a fresh attempt to identify the basic characteristics of rock-art—so that we can take another stab at relating it to something we recognize—we discover that generalizing is difficult. Marks are sometimes crowded in a heavily used spot; elsewhere, they are widely dispersed. Some rock-art seems positioned so as to be noticed; in other cases, it is concealed. Some marks are carefully executed; others seem to have been hastily dashed off. The same designs may appear at site after site over an enormous area, while other markings are unique. The more we observe, the more uncertain we become.

Rock-art in the Southwest is a tantalizing blend of contradiction and predictability. It's exciting—though perhaps a little unsettling—to recognize that there is nothing in our contemporary life quite equivalent, and to discover that questions about rock-art are not easily answered.

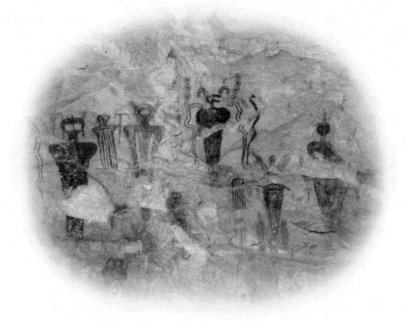

Who Made Rock-Art?

NATIVE AMERICANS have created virtually all of the rock-art in the Southwest and throughout the Americas. The nature of the rock-art designs, the site locations, the techniques used, and the ongoing traditions of Native Americans confirm this fact.

Native Americans of many different lifeways, languages, religions, and cultures have made rock-art. Petroglyphs and pictographs have been created in the Southwest since as early as 5000 BC—possibly even earlier—and in some places they are still being created today. Mobile bands of people who hunted and harvested wild foods made rock-art; so did people in small settlements and in large agricultural villages. Over the millennia, societies changed, new ideas emerged, and people and influences entered the region from other areas. Some groups prospered and others struggled. The Native American people of the Southwest made rock-art at many different points in time and under many different circumstances.

Men have customarily been portrayed as the makers of rock-art in the Southwest. The basis for this view is the assumption that activities away from residential areas—hunting, warfare, and lengthy rituals—tended to be in the domain of men. Additionally, the imagery shown in rock-art, such as individuals armed for hunting or fighting, and large game such as bighorn sheep and deer, often suggests men's occupations. Lately, however, this assumption has been challenged. It has been demonstrated that in historic times, women made rock-art, and women and girls had coming-of-age rites that involved it. Additionally, rock-art is often associated with seed-processing areas, which—even when situated away from residential locales—are believed to have been used chiefly by women. Thus, it is entirely reasonable to conclude that both women and men made and used rock-art in the prehistoric past.

EUROPEAN TRAVELERS AND SETTLERS also have made marks on rock throughout the Southwest. Many of these marks are numbers and letters giving initials, names, dates, and hometowns. Crosses and other Christian symbols also appear. Except when prehistoric designs are con-

sciously imitated, the marks made by Europeans in the Southwest usu-
ally are distinct from the rock-art of Native Americans.

**DID NON—NATIVE AMERICANS REACH THE SOUTHWEST BEFORE COLUMBUS
ARRIVED?** Although few archaeologists and anthropologists support this
notion, some researchers believe that—long before Columbus landed
in 1492—people crossed both the Atlantic and Pacific oceans and
reached the Southwest. Rock markings that some claim are inscriptions
in ancient languages are key evidence in this theory.

In the Southwest, one of the most famous of these inscriptions is the
"decalogue stone," or "mystery stone," near Los Lunas, New Mexico—a
boulder engraved with what has been identified as the Ten Command-
ments in a rough form of paleo-Hebrew. Detractors point out errors in
the way the language was written and say that the inscription was most
likely made as a prank by local university students.

In southeastern Colorado, linear rock-markings at some sites have
been interpreted as inscriptions in a Celtic language known as Ogam.
These markings—dated to 2,000 years ago or more—are likened to
Ogam inscriptions found in Ireland, Wales, Cornwall, and the Isle of
Man, and they have been interpreted by some as evidence of early Celtic
travelers in North America. Mainstream archaeologists discount this
analysis and believe that these "inscriptions" are examples of the linear
markings or tool-sharpening grooves characteristic of Native American
rock-art sites of the Archaic period (ca. 8000 BC–AD 500).

For more information on these and other archaeological outliers, see
Selected Web Sites, pages 151–153.

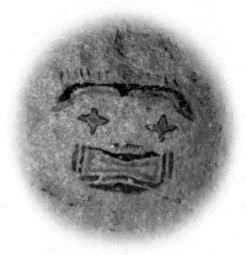

Rock-Art Styles

STYLE CLASSIFICATIONS FOR ROCK-ART are modern labels that are believed to reflect prehistoric realities. Classifying rock-art according to its "style" is one of the principal ways that researchers make sense of the range and diversity of rock-art designs.

Rock-art styles are based on patterns that have been identified in the way designs were selected, executed, and arranged in relation to one another. Because these distinctive patterns are assumed to be a result of the constraints of culture, the rock-art associated with a style is assumed to have all been made by the people of some definable cultural tradition. Thus, rock-art styles indicate who made the rock-art, and approximately when.

Each style encompasses significant variations, however, and there is considerable discussion about whether the rock-art at certain sites should be classified as one style or as another. Adjustments to stylistic categories continue to be made, and refining the date range for each style is an ongoing research effort.

The rock-art styles summarized on the following pages are those most frequently encountered at prehistoric sites in the Southwest. This is by no means an all-inclusive list. Its purpose is simply to mention the key features of commonly seen styles and to provide a brief sketch of the cultural group associated with each.

ANASAZI. The term Anasazi describes a long and complex cultural tradition located in and around the Four Corners region. The Anasazi tradition includes large and elaborate village sites, such as those found in Mesa Verde and Chaco Canyon, as well as thousands of smaller occupation and activity sites. Most contemporary Pueblo peoples trace their ancestry to the Anasazi.

Region: Sites are concentrated in the drainages of the San Juan, Little Colorado, and during the later period, the Rio Grande.

Period: AD 800 to 1300

Style Characteristics: Petroglyphs are most common, but pictographs also were created. Rock-art was made in close proximity to dwellings, as well as in remote locations. Panels are often highly complex groupings

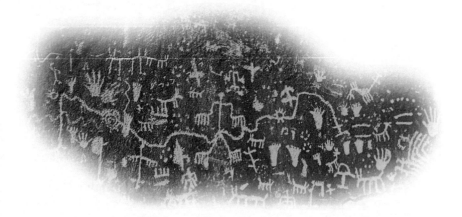

of figurative and non-figurative elements that may be linked by juxta-position or by long, meandering lines. Individual elements are not large, and anthropomorphs tend to be stick figures. The so-called kokopelli—an anthropomorph shown in profile with a humped back, playing a flute—appears with regularity. Zoomorphic images include sheep, birds and bird tracks, lizards, and snakes. Panels often include large numbers of circles, spirals, curvilinear forms, terraces, and geo-metric elements.

◎ TERMINOLOGY

anthropomorph a figure that resembles a human

curvilinear a design that uses curved lines

figurative a design composed of recognizable forms such as anthropomorphs, quadrupeds, and other identifiable representations

geometric a design that uses angled lines and shapes

grid a design that has criss-crossed parallel lines

ladder a figure consisting of a line or pair of lines that are crosshatched with shorter lines (not thought to represent a ladder literally)

megafauna large animals such as mastodons

ARCHAIC or **WESTERN ARCHAIC STYLE.** The Archaic period describes the occupation of the Southwest during the several-thousand-year period between mastodons and maize. People of the Archaic period adapted to an environment that no longer supported megafauna, and they developed technologies to process a wide range of wild plant foods. Sites from the Archaic period are found throughout the Southwest. Archaic-

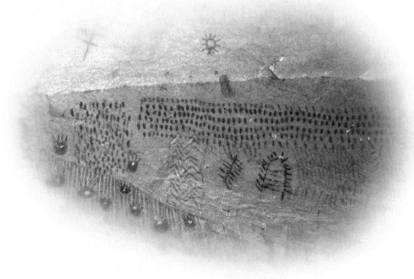

non-figurative a design composed of shapes and lines (such as squiggles, grids, circles, and dots) that do not directly portray identifiable items

panel a grouping of rock-art markings or designs, usually on one face of a boulder or in one section of a rock surface

pipette a figure, named for a piece of chemistry equipment, which consists of parallel lines that occasionally flare into rectangular sections

quadruped a four-legged animal

rake a figure consisting of a single line with a row of shorter lines extending from it along one side (not thought to represent a rake literally)

zoomorph a figure portraying an animal; sometimes used as an inclusive term and sometimes used to describe a figure whose exact identity is unclear

style rock-art may offer the best clues into the richness and diversity of life during this ancient period.

Region: Southwest

Period: 5500 BC to AD 500

Style Characteristics: The style is generally characterized by non-figurative designs. Markings may conform to natural features on the rock surface such as edges or cavities. Designs are both curvilinear and geometric, and can include many small ticks or scratches arranged in lines. Grids, "rakes," "ladders," and concentric circles also appear with some frequency.

BARRIER CANYON STYLE. One of the most distinctive of the rock-art styles—Barrier Canyon Style—was produced by hunter-gather people of the later phases of the Archaic period. Contemporary peoples such as Utes, Paiutes, and Shoshones, who were the most recent Native American occupants of the regions where Barrier Canyon rock-art is found, have a particular affinity for the sites.

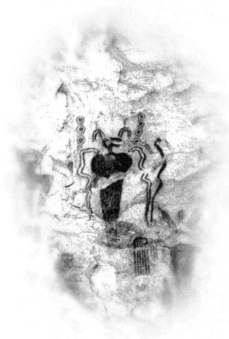

Region: Colorado, Utah, and northern Arizona, primarily in canyons of tributaries of the Colorado and Green rivers.

Period: Early dates for the Barrier Canyon Style range widely, with some as early as 4500 BC. Others assert that the style began around 1000 BC. The style appears to continue to the end of the Archaic period, around AD 500.

Style Characteristics: Petroglyphs as well as pictographs are evident, but the style is dominated by paint-

ed figures in black and red. In some panels, pecking and painting are combined. The most distinctive feature of the Barrier Canyon Style is the presence of elongated, imposing anthropomorphs, some over six feet tall. They have broad shoulders and tapering bodies. Heads are bulbous, and faces are often nothing more than two large eye-like circles. There are sometimes horns or other appendages extending from the mask-like heads. Arms and legs are abbreviated, and bodies may be filled in or, more frequently, may show vertical stripes or other kinds of interior designs. These figures are often characterized as having an "other-worldly" aspect. Other designs—often adjacent to the anthropomorphs—include parallel lines, dots, and plant-like designs. Bird and animal forms are sometimes present.

BASKETMAKER. The Basketmaker tradition in the Four Corners region marks the transition between wild food dependence and agriculture. The Basketmaker period is subdivided into two basic phases, Basketmaker II and Basketmaker III. The earliest Basketmaker sites bear a close resemblance to the sites of the Archaic tradition that preceded it. Throughout the Basketmaker period, increasing orientation toward crop-growing is evident as settlements became more permanent, and greater quantities of ceramics were made.

Region: Basketmaker sites are found throughout the Four Corners region. The distinctive San Juan Basketmaker rock-art style is concentrated in the drainage of the San Juan River in Utah, Colorado, and northern Arizona.

Period: Basketmaker II: 1000 BC to AD 500; Basketmaker III: AD 500 to 750

Style Characteristics: Mostly petroglyphs and some pictographs survive. Petroglyph panels include human forms with trapezoidal bodies and prominent necklaces, headdresses, and ear decorations. Basketmaker rock-art often has numerous figures combined on panels, including humans in profile appearing to play flutes. Other anthropomorphs are arranged in rows. Decorated faces—both painted and pecked—have been interpreted as scalps. Birds, reptiles, and quadrupeds are all present.

COSO RANGE. The rock-art in the Coso Range of Southeastern California was made over a span of thousands of years by people who were adapted to an arid and challenging environment. Agriculture was never practiced in this region, and groups were, for the most part, small and mobile. While the people who produced the rock-art were part of larger networks of cultural influence, the rock-art of the Cosos remained distinctive.

Region: Coso Range and nearby regions

Period: Although some extremely early dates have been proposed for the oldest Coso Range rock-art—as early as 19,000 years ago—most of the images are believed to have been made after AD 500 when the bow and arrow was first used in the area.

Style Characteristics: Coso Range-style rock art consists almost exclusively of petroglyphs. Depictions of bighorn sheep, constituting more than half of all images, dominate the style. Coso bighorn sheep are distinctive in the way that the curved horns are shown as though the animal's head is turned toward you. Other elements include a variety of anthropomorphic designs, some with elaborate head appendages and body decorations.

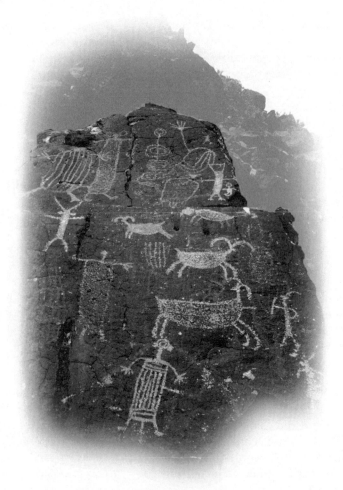

FREMONT. The Fremont tradition is the northwestern variant of the widespread transition to settled agricultural life that occurred throughout the Southwest after AD 400. The Fremont people were agriculturalists who also hunted and gathered wild foods to supplement their corn crops. They typically lived in pit-houses with associated masonry or adobe "granaries" that were used for the storage of food. A distinctive type of small clay figurine is associated with Fremont archaeological sites, and some Fremont-style rock-art includes designs that look very similar to the figurines.

Region: Central and northern Utah

Period: AD 400 to 1350

Style Characteristics: Fremont-style rock-art includes both petroglyphs and pictographs, although petroglyphs predominate. Characteristic designs include large human-like figures with trapezoidal bodies and elaborate necklaces. Some figures have large shields; others have horns. Design groupings often show several figures that apparently interrelate. Some Fremont-style rock-art has been said to show "hunting scenes" because of the interaction of animal and human figures.

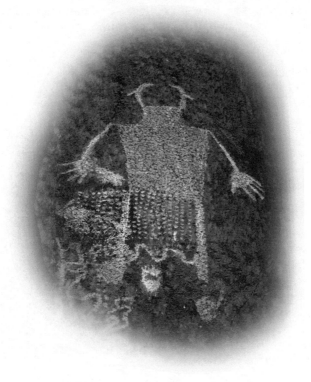

HOHOKAM STYLE, or GILA STYLE. Rock-art of the Hohokam *(Ho-ho-kam')* style, or Gila *(Hee'-la)* style, is associated with the Hohokam people of central and southern Arizona. These desert agriculturalists lived in hamlets and villages established around major ceremonial centers. They used water from desert rivers and streams to irrigate their crops by means of an extensive system of canals. Today, the people of the Gila River Indian Community, the Salt River Pima–Maricopa Community, and the Tohono O'odham nation consider themselves descendants of the Hohokam. People of the Hopi tribe in northern Arizona also trace the history of some Hopi clans to the Hohokam.

Region: Southern and central Arizona

Period: AD 300 to 1450

Style Characteristics: Hohokam or Gila style rock-art involves only petroglyphs. Human-like forms usually resemble stick figures or have hourglass-shaped bodies and are often shown in "active" poses, such as with bent arms and legs. Bird forms appear, along with reptiles, amphibians, and insects. A distinctive motif is called the pipette design—parallel vertical lines that occasionally flare into rectangular sections. The pipette motif is thought to be related to the Mexican deity Tlaloc. Some Hohokam rock-art designs are similar to patterns found on Hohokam pottery and textiles. Many panels are crowded and show evidence of designs being made at different times.

JORNADA MOGOLLON. The Jornada *(Hor-nah'-dah)* style is at the southeastern edge of the larger area encompassed by the Mogollon *(Mug-ee-un')* tradition. The Mogollon tradition is roughly contemporaneous with Anasazi and Hohokam, and describes agricultural adaptations to the mountainous upland regions of eastern Arizona, southwestern New Mexico, and far west Texas. Sites associated with the Jornada style indicate less dependence on agriculture and greater reliance on wild game and plants. Both petroglyphs and pictographs were made in the Jornada style.

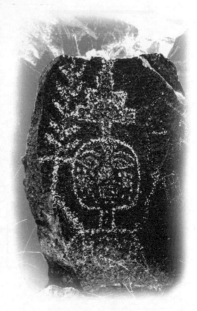

Region: Southern New Mexico, west Texas

Period: AD 500 to 1450

Style Characteristics: Jornada style rock-art is distinctive for its detailed depictions of life forms, including bighorn sheep, mountain lions, dogs, rodents, reptiles, fish, insects, and birds. Human forms often have detailed facial features or mask-like designs. One characteristic motif is the design identified as Tlaloc, a deity in Mesoamerican religions associated with rain. The key quality of Jornada style Tlaloc figures is huge circular eyes atop a large body without extremities.

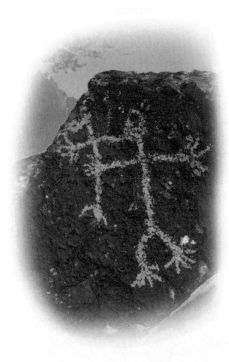

PATAYAN. Western Arizona includes the agriculturally productive Colorado River valley, as well as hot and rugged deserts. Subsequent to the Archaic period, people practiced ways of life that included agriculture as well as an adaptation to more marginal areas. Today, tribes including the Yavapai, the Hualapai, and the Havasupai have particular interest in the management and preservation of sites in this area.

Region: Colorado River valley and western Arizona.

Period: AD 500 to 1400

Style Characteristics: Patayan rock-art is most distinctive in the presence of anthropomorphs that have large and prominent hands and feet. Geometric designs include single and double crosses with outlines, and concentric circles.

RIO GRANDE. In the late prehistoric period, beginning around AD 1300, Anasazi groups began populating the fertile Rio Grande Valley. These groups were well established at the time of the Spanish entrance into the area, and most groups have continued there into the modern era. Although collectively called Pueblo people, there is pronounced diversity in language, religious organization, and social structure. Rock-art sites remain of central importance to contemporary Pueblo people as part of their sacred relationship with the land.

Region: Rio Grande Valley in northern and central New Mexico
Period: AD 1300 to the present
Style Characteristics: Petroglyphs predominate, but pictographs are found in some sheltered areas. Sites can be extensive and include numerous designs. Elements are frequently discrete, with a limited amount of superpositioning or apparent interaction among figures. Anthropomorphs are often full-bodied with details of clothing and elements such as wands, feathers, and shields. Many kachina faces appear, some with details that allow them to be identified specifically. Animals, too, are detailed and usually identifiable. Geometric designs include prominent terraced forms, circles, and spirals.

SINAGUA STYLE. The sites identified as Sinagua *(Si-nah'-wa)* are concentrated around Flagstaff and the Verde Valley in Arizona. Sinagua sites suggest complex cultural interchanges, with the presence of ball courts pointing to connections with the Hohokam to the south, and ceramics and masonry techniques indicating contact with people to the north. Sinagua sites include Montezuma's Castle, Montezuma's Well, Tuzigoot, and Wupatki. Contemporary Hopi and Yavapai peoples have strong traditions associating them with the areas in which Sinagua sites are found.

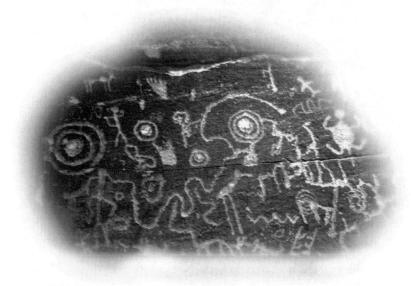

Region: Central Arizona, especially around Flagstaff and the Verde River Valley

Period: AD 650 to 1450

Style Characteristics: Mainly petroglyphs, but also some pictographs, are found in Sinagua-style rock-art, which includes anthropomorphic, zoomorphic, and geometric designs. Sinagua-style anthropomorphs are typically stick figures, some with head ornaments; feet are often represented, but hands and fingers are not. Zoomorphs include deer, elk, and bighorn sheep, and sometimes dogs or coyotes, but birds are rare. Many designs resemble lizards, horned toads, and snakes. Zoomorphs often have full, rounded bodies. Panels are often concentrated with many designs packed closely together. Pictographs frequently include hand designs in the form of direct prints, stencils, and patterned prints. Particularly notable are large circular "sun" or "shield" designs.

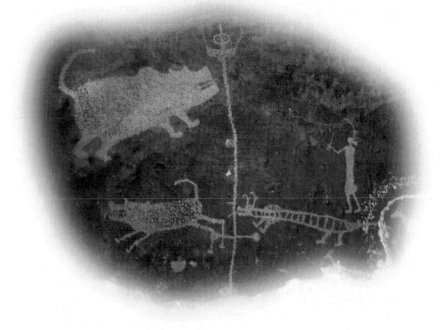

Determining the Age of Rock-Art

ROCK-ART'S AGE is more difficult to establish than you might imagine. Many of the best methods for determining the age of archaeological antiquities simply do not work well on pictographs and petroglyphs.

Most age-estimation methods used for rock-art are only able to give *relative* dates—they conclude that a particular piece of rock-art is "older than" or "younger than" something else. Many methods result in very broad date ranges. Still others are so imprecise that they can offer only a very general sense of the age of the work.

The dating problem is a frustrating barrier to a fuller understanding of Southwestern petroglyphs and pictographs (and the rock-art of many other places, as well). If accurate dates could be determined easily and reliably, rock-art could be integrated more meaningfully into the rest of the archaeological and historical record.

This section gives an overview of the primary ways in which the age of Southwestern rock-art is estimated. A few of these dating methods can be used for rock-art in many situations, while others can be employed only under special conditions. Often, several approaches to date estimation are used together, as no single method alone may be sufficient. New methods for dating rock-art also arise from time to time, and old methods are refined and improved. Someday, more reliable techniques probably will be developed. For now, experts agree that most rock-art dates are guesses—rough estimates—and the likelihood is high that many current dates eventually will be reevaluated and revised.

IDENTIFYING THE ROCK-ART STYLE is probably the most common method for assigning dates to Southwestern petroglyphs and pictographs. Specific, observable characteristics define each named rock-art style, and each style is associated with a particular date range (see **Rock-Art Styles**, pages 45–55).

Once the defining criteria have been established for a particular rock-art style in a region, all petroglyphs or pictographs that fit within that style are assumed to have been made during the same time period.

NATIVE AMERICAN ORAL HISTORY AND TRADITIONAL KNOWLEDGE also can shed light on the age of rock-art. For instance, such knowledge may help establish that certain rock-art is modern or only a generation or two old, rather than centuries old. Or, it may demonstrate a connection between present-day cultures and the rock-art—a connection that may help guide theories about which group probably made it, and when. Today, knowledgeable Native American tribal specialists increasingly take part in collaborative efforts with anthropologists, archaeologists, and historians to widen and deepen understanding of particular rock-art sites.

LINKING ROCK-ART TO DATABLE ARTIFACTS is another way to estimate its age. If pictographs or petroglyphs can be associated with other material for which reliable dates have been established, the rock-art's age can be inferred on the basis of that connection.

At prehistoric habitation sites, archaeologists use carefully controlled methods to determine chronologies of architectural construction, artifact use and disposal, and other activities that took place at the site. Generally, studies are based on the site's stratigraphy—its layers of deposits. A fundamental principle of this approach is that older material lies beneath more recent material. Sometimes, a stratum or layer at a site contains artifacts—such as potsherds—that are especially strong indicators of particular time periods. Or the stratum may contain wood, charcoal, a hearth, or some other feature that can be dated. By this means, the occupation periods of many prehistoric sites in the Southwest have been determined.

But how does this help date rock-art, which is very rarely part of a site's stratigraphy? Such dating is done by inference. Sometimes the association between a rock-art site and a well-dated archaeological site is strong. The sites may exist in close proximity to one another, or the imagery in the rock-art may correspond to imagery associated with the habitation site. In such cases, it may be tentatively concluded that the rock-art is contemporaneous with the archaeological site, and therefore,

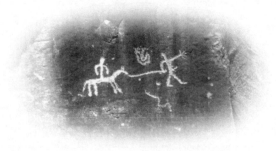

the date associated with the site can be assigned to the rock-art. Of course this kind of dating is based on circumstantial evidence—but sometimes it's the best basis available.

Once in a while, the association is even stronger. In a few instances, archaeologists have found datable materials in direct contact with rock-art—for instance, in deposits at the base of a petroglyph panel. If the petroglyph marks extend into the datable stratum, it can be surmised that the petroglyphs are older than the deposits. The rock-art would have been made first, and afterward, people's activities and natural erosion processes would have caused material to accumulate at the base of the petroglyph, enough to actually bury part of it.

IDENTIFYING DATABLE DESIGN ELEMENTS can allow us to place a "no older than" date on certain images. For instance, rock-art that includes horses or that shows people wearing brimmed cowboy hats cannot have been made before those non-indigenous items (horses and cowboy hats) appeared in North America. Thus, when these subjects are depicted in rock-art, it can be concluded that the designs date—at the very earliest—to the time of the items' introduction, and definitely not to any time earlier.

Other datable design elements include rare or unique events. For instance, in AD 1054, a "star" six times brighter than Venus was seen in the sky for more than three weeks. This supernova—known today as the Crab Nebula—appears to have been recorded in a pictograph in Chaco Canyon, in New Mexico. Its position next to a crescent moon corresponds to what would have been seen from that place in early July 1054.

STUDYING SUPERIMPOSED DESIGNS also helps establish the relative age of the rock-art involved. Obviously, a petroglyph or pictograph made atop another rock-art design postdates the material underneath it. The study of superimposed rock-art is solely a relative dating technique—it can only be used to conclude that the lower design was made earlier than the upper design. However, superimposed rock-art designs have been used to reinforce other broader conjectures about dates; for example, they may help to confirm the date sequence for the rock-art styles in a region.

COMPARING THE DARKNESS OF PETROGLYPHS is a longstanding and very common way to assess the relative age of rock-art at a site: dark-colored petroglyphs are considered to be older than light-colored ones. This dating method is based on the fact that black- or brown-colored rock

varnish builds up gradually in an ongoing process that causes the rock surface to become darker and darker over time. (See **What Is Rock Varnish?** pages 25–26.)

A petroglyph is at its lightest right after being made. The surface stains and other natural coatings on the rock outcrop or boulder are removed by the pecking or abrading of the petroglyph-making process, and the lighter color of the rock's interior is exposed. However, just as the continually forming rock varnish thickens its deposit on the unworked parts of the rock, it also accumulates on the freshly worked, light-colored surface. After about a century, the accumulation becomes visible. And the longer it has been since the petroglyph was made, the more time there has been for rock varnish to accumulate over it. Thus, at a given site, darker petroglyphs are assumed to be older.

At certain rock-art sites in the Southwest, people kept making petroglyphs over very long periods of time. One clue to such sites is the presence of petroglyphs of varying darkness, or having different "degrees of patination," as it is sometimes phrased. Additional evidence may reinforce this hypothesis: the co-existence of different rock-art styles associated with different dates, the presence of superimposed rock-art designs, or position changes for some of the rocks at the site.

POSITION CHANGES OF ROCKS can also give clues to the relative ages of rock-art. A boulder with petroglyphs on its underside, or with designs in a currently inaccessible place, has undoubtedly undergone a change in its position. Boulders often overturn or even tumble down slopes, their motion triggered by natural forces or by human acts. At some sites, the same boulder—in its new position—has been used for additional rock-art. Clearly, the marks that are underneath or in unreachable places predate marks that are presently accessible.

This information can be useful for dating beyond that single boulder. The rock's changed position, and the point in time it documents (the moment it moved), can help distinguish between separate rock-art styles at a site—information that can be drawn upon in understanding other sites within the same area that have similar rock-art.

MEASURING LICHEN GROWTH may be helpful in estimating the age of petroglyphs. It has long been recognized that lichen grows extremely slowly on rock surfaces—so when lichen-covered petroglyphs have been found, observers have used that as a clue to infer that the petroglyphs are very old. "Lichenometry" has been proposed to reach more specific conclusions. Lichen growth rates for some species in some locales have been determined (generally, the lichen diameters increase on the order

of 7.5–15 millimeters per century), and this evidence can be used to estimate the "youngest" that a particular petroglyph can be. For example, if the diameters of lichens growing on top of the petroglyph's worked area indicate that that lichen has been growing for 350 years, it can be concluded that the youngest the petroglyph could be is 350 years. Of course, it may be older, depending on when the lichen growth began.

CATION-RATIO DATING, sometimes called CR dating, is a relatively new technique in which the chemical composition of rock varnish collected from the surface of a petroglyph is analyzed (see **What Is Rock Varnish?** pages 25–26). CR dating is based on the fact that over time, weathering processes remove some cations (positively charged ions) from rock varnish more quickly than others. Specifically, potassium (K) and calcium (Ca) cations are leached out more quickly than titanium (Ti) cations. The "ratio" sought from the analysis of the varnish is defined as the sum of the potassium cations and the calcium cations, divided by the quantity of titanium cations: $(K^+ + Ca^{+2}) \div Ti^{+4}$.

The cation ratio is useful for dating because it changes over time in a predictable way. Thus, in a given locale, older rock varnish has a lower cation ratio than younger rock varnish. And, in turn, older petroglyphs are presumed to lie below older rock varnish, whereas younger petroglyphs are presumed to lie below younger rock varnish.

Researchers using CR dating have worked to correlate "absolute dates" from other sources with cation ratios (which offer, for a particular area, relative ages only). When enough absolute dates can be paired with cation ratios, a graph (sometimes called a "cation ratio curve" or a "cation leaching curve") can be created for a particular area; such a graph allows a researcher with a cation ratio for a sample of rock varnish to find its actual age. Rock-art researchers around the world are working to refine this technique and develop cation ratio curves for various areas.

RADIOCARBON DATING, also known as carbon-14 dating, is a method so powerful that it has completely transformed our understanding of the past since its development in the late 1940s. This dating method analyzes carbon-containing ("organic") substances—material from virtually any portion or part of a plant or animal. Radiocarbon dating determines when that plant or animal stopped growing; that is, the date it died or was harvested.

But what does the death date or harvest date of an animal or plant have to do with the age of rock-art? How can this venerable technique

be used for dating petroglyphs and pictographs? Unfortunately, applications are limited, testing is costly, and results are often questioned. Still, radiocarbon dating is occasionally used to help date rock-art—and it has been experimented with in interesting ways.

Pictographs offer the most obvious materials for radiocarbon dating. Charcoal or soot from burned wood, which may have been used as a black colorant, can be sampled for dating. So can blood, resins, oils, fats, or waxes, which sometimes were used for paint binders (see **Pictographs,** pages 18–22). To have radiocarbon dating performed, a bit of the datable material is removed from the pictograph and sent to a special laboratory for analysis. It can be difficult to gather a sample large enough for dating—in many cases, the paint in pictographs is more like a stain on the rock than a discrete layer on the surface. Samples are easily contaminated—inadvertently, of course—by other carbon-based compounds that have accidentally mixed into the material collected for dating. For instance, carbonates in the rock may affect the sample, as may organic materials that infiltrated the rock-art after it was made. Third, sample-taking is inevitably slightly damaging to the work. Finally, analysis is costly. These problems have meant that radiocarbon dating has been used for only a small number of pictographs.

Petroglyph dating has also been attempted using radiocarbon analysis, but in the late 1990s, this technique—once considered promising—was discontinued. Because results from the method are sometimes still cited, it is important to understand both the concept behind it and its shortcomings. The method—usually called AMS radiocarbon dating, in reference to the accelerator mass spectrometry (AMS) used in the analysis—was based on the idea that as rock varnish accumulated over a petroglyph, it could encapsulate small particles of datable organic material. If the age of organic material overlying a petroglyph could be established, the rock-art could be inferred to be "at least as old as" that datable organic speck. Using an electron microscope and microprobe, tiny amounts of organic material positioned between the rock and the varnish were detected, isolated, and tested. Ultimately, the procedure was found to yield inaccurate dates, and it could not be determined whether samples had been contaminated by older carbon-containing compounds leaching from the rock or by younger carbon from the atmosphere.

Why Was Rock-Art Made?

WHAT KINDS OF ACTIVITIES spurred the creation of Southwestern rock-art? And how can something so complex and enigmatic be explained without living informants? In rock-art study, these questions are the focus of ongoing discussion and debate.

Ideas about why Southwestern rock-art was made have emerged from several different lines of evidence. On the one hand, interpretations may be based on regional archaeological studies and information from local Native American authorities. On the other hand, explanations may have their foundation in worldwide studies of both ancient and modern rock-art. Some concepts—such as sky-watching—are based on well-documented cultural practices in the Southwest and depend on the presence of particular site features.

Other explanations—such as the association of rock-art with shamanic religious practices—offer a broad-based framework for explaining the rock-art of many regions and time periods throughout the world.

Every explanatory framework has its own history, supporting evidence, adherents, and critics. It is important to recognize that different explanations are not necessarily competing or mutually exclusive. Ideas that seem separate may actually be related facets of a larger concept whose totality is not yet clear to us. At sites that have been used over long periods, more than one interpretation may be applicable. It is also entirely possible that some of the reasons for making rock-art have yet to be recognized.

The interpretations discussed here are those currently most prevalent. All involve complex evidence, analyses, and arguments too detailed to cover completely in this work, but these summaries offer a general sense of the concepts and the reasoning behind them.

ROCK WRITING. What were they communicating? is a question frequently asked at rock-art sites. The tendency to assume that each rock-art design stands for something can lead to the idea that—as with language—lengthy "statements" have been constructed from individual "words."

Approaching rock-art as a form of sign language goes back at least as far as Garrick Mallery in the nineteenth century. According to this view, rock-art is a messaging system in which marks made by one person could later be "read" by another person who knew the same vocabulary of symbols. Today, numerous books still offer dictionary-like presentations of rock-art designs and what they "mean."

However, the idea that a one-to-one correspondence exists between meanings and rock-art designs is an oversimplification of rich and complex symbols. Calling a particular rock-art design a "sheep," a "cloud," or a "shaman" merely associates an ancient design with concepts understandable to modern English speakers. Lost is the possibility that, as in contemporary Native American imagery, animals are likely to have associations with particular human qualities or with social groups such as clans. The full complex of meanings that originally accompanied the design is never captured in a simplistic translation. When distance in time is added to difference in culture, the complications mount.

Some investigators have attempted to translate rock-art by likening it to the "gesture language" of hand-signing used by Native Americans on the Great Plains and in some parts of the Southwest. Each hand gesture had a particular meaning, and even people who spoke different languages could communicate as long as they understood the stan-

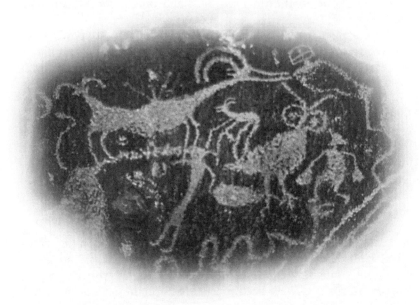

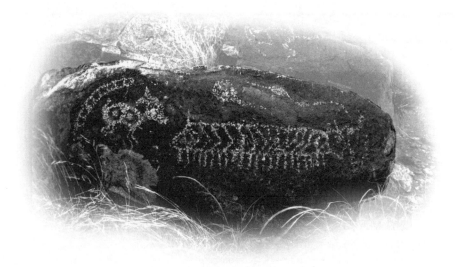

dardized meanings of the gestures. In this framework, rock-art panels are examined for features that seem to be consistent with standardization. For instance, the ubiquity of bighorn-sheep figures has been explained as being a "neutral message vehicle" used to indicate direction of travel. Body forms and horn configurations, it is argued, show both the direction and difficulty of travel. Using such an approach, whole panels are "deciphered."

Such explicit interpretations have been regarded with a great deal of skepticism. The detailed nature of the translations of these stylized figures makes it very difficult for the interpretive system to be applied in a consistent way. Because the vast majority of Southwestern rock-art substantially predates the historic period, most researchers feel that no one today can translate its meanings with complete confidence.

There is another, separate area of potential misunderstanding about the meaning of individual designs. Some of the names commonly associated with rock-art designs come from rock-art researchers' shorthand terms for frequently seen designs. When describing rock-art of the Archaic period, for instance, "ladders" and "rakes" are usually mentioned. Neither of these terms is meant to suggest that people in the Archaic period were depicting the tools we know today as rakes and ladders. In rock-art terminology, a ladder is a design with one or two vertical lines with shorter crossing lines. A rake is a horizontal line with shorter vertical lines attached to it on one side.

REFERENCE TO STORIES OR MYTHS is thought to have been the reason that some rock-art was created. When present-day Native American people have been asked how they interpret the ancient rock-art in their region, they often reply that it pertains to gods and other characters known from histories, myths, and other oral traditions.

In New Mexico, modern Zuni people who were asked about rock-art in their area ascribed it to the long-ago time when animals could speak with people. For contemporary Zunis, observing this ancient rock-art has often stimulated the recounting of stories about mythical events or creatures.

Myths are oral traditions that explain how the world came to be. They usually describe events that took place outside of ordinary historical time. Although myths may be set in the very remote past, the characters in myths usually exist in the present as supernaturals—as gods. And although myths describe events that took place long ago, they explain the state of the world in the present, addressing such fundamental human concerns as death, health, and social obligations.

Another way in which rock-art is connected to stories and oral traditions has been in the depiction of actual events. Some pictographs made by Navajo people, for instance, show figures that appear to be wearing European clothing mounted on horseback. These have been interpreted as Spanish conquistadors during their exploration of the region.

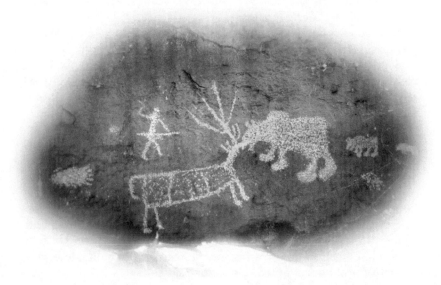

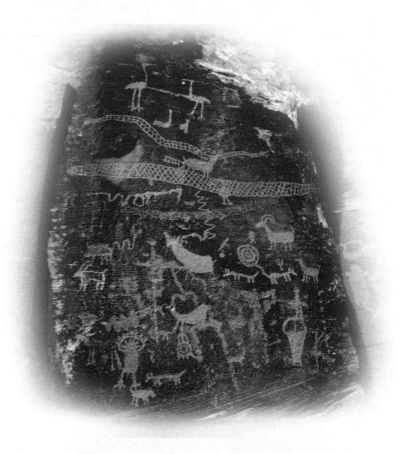

When people question whether rock-art portrays myths and stories, they raise several issues. First, rock-art designs rarely seem to show complete narrative illustrations. Second, it is not clear that rock-art images have a literal "meaning" that can be deciphered. It seems more consistent with the evidence to regard rock-art pertaining to stories and mythology as symbolic and suggestive rather than directly illustrative.

HUNTING for deer, bighorn sheep, pronghorns, and elk was the way hides and large quantities of meat were obtained by Native Americans in the Southwest. These animals were hunted on foot, using a bow and arrow or a spear and atlatl (spear-thrower). Rabbits and birds were much easier to obtain and were eaten more frequently, but the larger animals were highly desirable game.

When rock-art researchers noted how commonly large game animals were pictured in the Southwest, a long-standing interpretation of rock-art from other places around the world was proposed as an explanation: "sympathetic hunting magic." According to this theory, a believer depicted a hoped-for occurrence (locating and killing game) because doing so in the proper manner would influence the future—game would be encountered, and the hunt would be successful.

In addition to the frequent portrayals of deer, bighorn sheep, pronghorns, and elk in Southwestern rock-art, many sites were close to what researchers believed were good places for hunting. Some of these locales had linear constructions that seemed suitable for driving game during organized ambushes, or small stone circles believed to be remnants of hunting blinds. These features added support to the idea that rock-art was connected to the act of hunting large game.

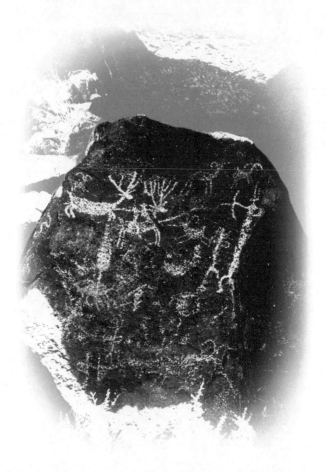

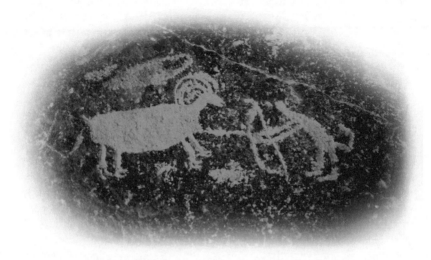

Rock-art sites near water (which is usually associated with game trails or animal migration routes) were also seen as support for a connection between hunting and rock-art. These were presumed to be places where hunters could reliably encounter game.

And when animals were depicted in rock-art at sites that lacked characteristics of hunting locales, the proponents of sympathetic hunting magic had an explanation: the sites were related to ceremonies for increasing the population of these desirable animals.

The hunting-magic theory has been questioned for a number of reasons. The strongest criticism is that the animals most often portrayed, either as figures or as tracks, actually had a limited role in subsistence and other economic activities. Bighorn sheep are, by far, the most frequently depicted animals in the Southwest, and yet rarely did they make more than a minor contribution to people's diets.

Moreover, the idea that rock-art sites are frequently in good hunting areas has been questioned, and more thorough investigations have shown that many of the places once thought to have been special hunting locales actually were not.

The hunting-magic theory also does not take into consideration the fact that animal designs may not mean what they literally portray. They may, instead, be metaphorical and suggestive of more subtle concepts— the way the profile of an elephant emblazoned with stars is readily recognized as symbolizing the Republican Party.

Finally, there is no historic or ethnographic record in the Southwest of "sympathetic hunting magic" activities being conducted.

SKY-WATCHING is known to have been an important activity in the ancient Southwest. Prehistoric people monitored the sun's position in relation to Earth, and some rock-art sites contain features that align with the sun at key points in its annual cycle. Other sky-watching involved stars, planets, and the moon, and some rock-art sites may also involve those observations.

In historic times, in the villages of agricultural people such as the Hopi and Zuni, certain individuals were responsible for observing the position of the sun throughout the year. Observations might be made directly, by noting where the rising sun appeared on the horizon. In some cases, indirect observations were made. For instance, specially constructed holes or windows in a room were aligned with the sun's position on a key date such that the rays would shine on a certain mark within the room. Prehistoric buildings have also been shown to incorporate such features. Increasingly, it is being discovered that some rock-art sites also functioned in this way.

At rock-art sites with this purpose, light and shadow effects at certain times of the year might interact with a petroglyph or pictograph that was created to serve as an indicator of the date. For instance, on a solstice date, the sun might cast a shadow in such a way that it bisects a spiral petroglyph. Or, light might shine through a gap in the rocks in such a way that a "dagger" of light touches a painted design. (See the Rock-Art Solar Markers site listing under **Selected Web Sites,** page 153.)

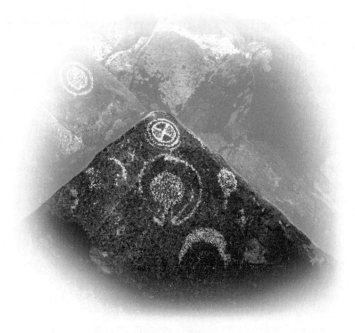

The most significant points in time for sun-watching seem to have been:

- *winter solstice,* approximately December 21, when the sun rises at the southernmost point on the horizon

- *summer solstice,* approximately June 21, when the sun rises at the northernmost point on the horizon

- *spring (or vernal) equinox,* approximately March 20, when day and night are of equal length

- *fall (or autumnal) equinox,* approximately September 23, when day and night are of equal length

- *cross-quarter points,* approximately February 4, May 5, August 7, and November 6; halfway between equinox and solstice dates

Why were people so interested in the various points in the sun's annual cycle? The most likely reason is that there was a connection between knowing the sun's cycle and optimizing agriculture. Many ceremonial events tied to agriculture also were timed according to the solstices and equinoxes.

Is it correct to call these sites "calendars"? Probably not. Some researchers note that people who live close to the land make use of a wide range of observations to chart the passing of the seasons. Thus, sky-watching rock-art sites may have been more akin to shrines than to purely utilitarian calendars.

Other kinds of sky-watching involved stars, planets, and the moon. In northeastern New Mexico, some sites attributed to Navajo people consist of elaborate "star charts" in which dozens of crosses and dots are painted on the ceilings of rock shelters. And in several places in the Southwest, a famous supernova that was visible in the summer of AD 1054 is thought to have been depicted.

Critics of the sky-watching interpretation point out that at complex sites, researchers looking for indications of celestial study by ancient peoples may be finding purely coincidental relationships between the site and sky features.

IDENTITY MARKING is an explanation posited for some rock-art in the Southwest. Marks thought to have been made for that purpose are typically found on prominent points in the landscape and along trails.

Ethnographic evidence in the Southwest indicates that this kind of rock-art making took place into the historic period. Hopi people often make religious pilgrimages to locales that also have been visited by their forebears over many generations. On these trips, marks indicating travelers' clans were made on certain boulders along the way, and over time, the stones have become densely covered with petroglyphs. Hopi clan symbols include such designs as a corn plant, a raincloud, and a badger paw.

Similarly, the frequent association of rock-art with sources of water has led to interpretations that some marks at such sites were made by ancient travelers who were indicating that they had been present at a significant spot.

Marks of identity may also explain petroglyphs high on canyon walls in southern Utah, which have been associated with caches of materials. The markings may indicate to passers-by whose goods were stored nearby.

The presence of rock-art adjacent to habitations—particularly in prominent locations, such as on a cliff wall above living quarters— has lent further support to the idea of marks made to signal identity. These marks have been postulated to indicate a family, a clan, an affiliation, or some other individual or group identity. The problem with this explanation is that—except where there is a strong continuity into historic times, as with the Hopi clan markings—there is no evidence to corroborate the interpretation.

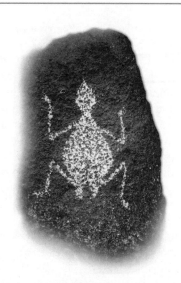

SHAMANISM is believed by many to be the explanation for rock-art and rock-art sites—in the Southwest, and in other places worldwide. For advocates of this interpretation, rock-art has its origin in the experiences of the trance state.

"Shamanism" refers to a particular way in which religious beliefs and practices are integrated into a society. The most distinctive feature

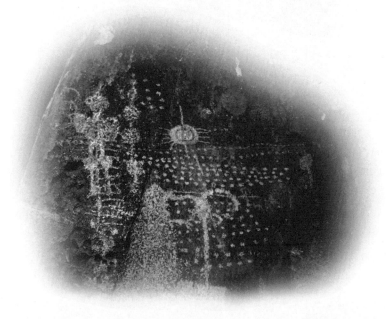

of shamanism is that certain individuals—shamans—are recognized as having the ability to "travel" to a supernatural realm that is not ordinarily accessible to human beings.

A shaman enters what is termed an altered state of consciousness—a trance—in order to make connection with the supernatural world. While in the spirit realm, the shaman enlists the aid of spirit helpers and becomes able to cure (or cause) illness, influence natural forces such as the weather or animals, and foretell future events. A shaman may also struggle with rival shamans while in the spirit realm. Additionally, shamans occasionally facilitate altered states of consciousness in others; for example, this might occur during curing ceremonies or as a part of coming-of-age rituals.

As a type of religious practice, shamanism is often contrasted with religions centered around priesthoods, in which practitioners are carefully educated in doctrine, and ceremonies emphasize adherence to established patterns of religious observance. However, regardless of the dominant religion, there are people in all societies who are able to enter

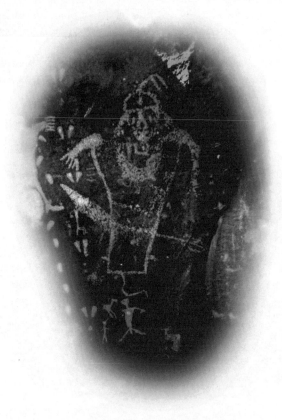

trances or "ecstatic" states. Depending on whether the prevailing belief system regards the supernatural domain as directly accessible to individuals, these people may or may not be accorded a role in religious activities. Some societies accommodate both priests and shamans, while others do not view trance experiences as legitimate.

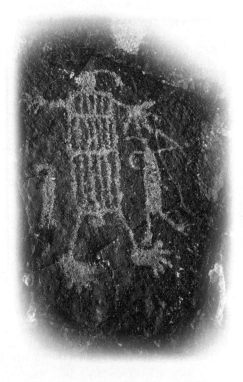

For most of us today, the idea of shamanic trances and of the powers that shamans acquired from spirits are very foreign concepts, as shamanism is not part of the major religions of our time. However, those beliefs and practices were undoubtedly very prevalent, if not universal, in prehistoric Native American cultures.

An altered state of consciousness (sometimes called an ASC) was entered by any of a number of means. Meditation, sleep deprivation, sensory deprivation, and psychoactive drugs are the kinds of aids used by shamans in many places throughout the world to bring about trance in themselves and others.

An altered state of consciousness has predictable physical sensations associated with it—at a base level, there is uniformity in the way human beings experience trance. For example, an altered state of consciousness often produces the feeling of flying, weightlessness, or drowning. A body may seem to change form between human, animal, and plant. The visual experience of trance typically includes experiencing tunnel vision and seeing objects outlined by auras of color, dots in patterned arrays, groups of wavy or straight lines, patterns of grids and dots, and flashes of light. Someone in a trance may also experience unusual sensations associated with their head.

Why has rock-art been associated with shamanism? Above all, the link has been made because of the kinds of designs that appear in rock-

art. Over and over, in many places and through many eras, rock-art imagery is consistent with the visual and physical experiences reported in trances. For example, many designs include characteristic patterns of lines and dots, combinations of humans and animals suggesting transformations, figures with elaborate appendages extending from their heads, auras and outlines, and winged creatures associated with human forms.

In this interpretive framework, rock-art is thought to record trance experiences. Exactly why the imagery from an altered state of consciousness would have been recorded on rock remains an open question. It is also not known who would have seen these images, and for what purposes they were made. A range of activities involving a shaman might have taken place at such rock-art sites, including initiation rituals, curing ceremonies, hunting preparations, warfare planning, and more.

Adding support to a tie between shamanism and rock-art is that shamanism is especially prevalent and elaborate in non-agricultural societies, and it also seems to predate religions based on priesthoods. These two features characterize Native American societies in the Southwest for most of prehistory. When combined with the belief that rock-art was primarily produced in the context of religious activities, an association between Southwestern rock-art and shamanism becomes a logical inference.

Critics of the shamanism theory feel that it is applied too universally. Some rock-art sites fit this model very well, but others do not. Furthermore, the association of rock-art with shamanism really does not explain *why* rock-art was made; rather, it only identifies its cultural context. Enthusiasm for shamanism as an explanation for rock-art worldwide has sometimes overwhelmed other ideas that may be better explanations for the petroglyphs and pictographs at particular sites.

FUTURE DIRECTIONS in understanding rock-art are hard to predict but interesting to contemplate. As rock-art research becomes more closely associated with mainstream archaeology, new approaches to interpretation are sure to develop. A particularly likely outcome is that there will be increased inquiry into how the production of rock-art relates to the dynamics of cultural change. For instance, is rock-art more likely to be made during times of cultural stress—indicated by evidence of warfare or population shifts—or during periods of relative calm? An important direction of research will be to explore how rock-art relates to the major social, economic, and ecological transitions that have occurred in the Southwest during the last several thousand years.

Central to this process will be to look beyond the rock-art itself. Just as contemporary archaeological analysis makes use of widely diverse data—from the layouts of rooms to grains of pollen in soil—rock-art research, too, will increasingly expand beyond its traditional sources of evidence. In seeking answers to the questions of who made rock-art and why, some investigators are employing large-scale geographic data to look for correspondences between rock-art sites and other landscape features. Others are doing fine-grained investigations of pecked surfaces to see if they can detect technological styles. With new analytical approaches, we can expect the interpretation of rock-art to enter new territory, and also to make a larger contribution to our understanding of Southwestern prehistory.

It will also be productive to conduct archaeological excavations at rock-art sites. Surprisingly, this has rarely been done. When it has, however, analysis of the stone tools, plant remains, and ceramics found by excavation has provided important information for understanding the kinds of cultural activities that occurred at the site.

Improvements in the sophistication of site documentation are around the corner. Many researchers are beginning to apply some of the advances that have been made in computerized mapping and digital imagery to the recording of sites. Such techniques will make studies of the interrelationships of elements and sites more powerful.

We are just beginning to see the results of collaborations between rock-art researchers and Native American people. As these relationships become stronger, our understanding rock-art is sure to grow. Not only can Native American people contribute directly to the interpretation of sites, they also help broaden the possibility for making reasonable hypotheses about the past.

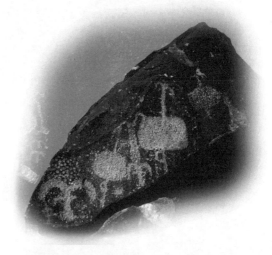

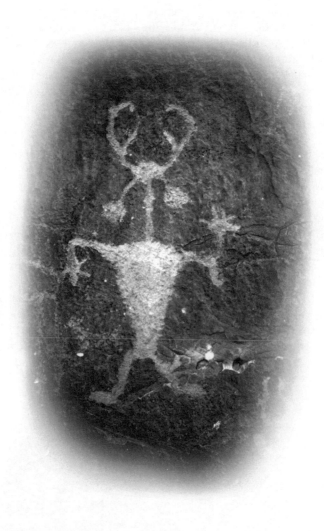

Protecting Rock-Art

Does Rock-Art Need Protection?

Visiting Rock-Art Sites
Visitor Guidelines • Photography •
Reporting Vandalism

Conservators: Specialists in Rock-Art Care

Native Americans' Concerns

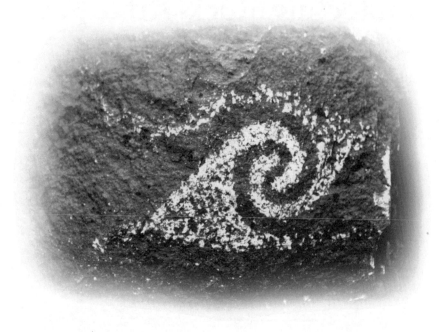

Does Rock-Art Need Protection?

WHY DOES ROCK-ART NEED PROTECTION? If you are new to visiting rock-art sites, you may be wondering whether rock-art really needs to be protected. After all, haven't countless Southwestern petroglyphs and pictographs survived in beautiful condition for hundreds and even thousands of years, with no special care whatsoever?

THE RAPIDLY CHANGING ENVIRONMENT is a crucial factor in understanding this issue. The setting in which Southwestern rock-art exists has changed significantly in the last century or two, and change has been dramatic during the past few decades. The region's population has grown at an unprecedented rate, and in many previously remote areas, the impact of modern life has been extensive. At the same time, outdoor recreational activities have become increasingly popular, and the number of people finding their way into the backcountry—on foot or in vehicles—is burgeoning. Construction, roads, and constant, increasing human activity suddenly surround petroglyphs, pictographs, and geoglyphs that were once far from the hubbub of contemporary life.

The effect on rock-art has been swift and severe. In studies conducted at a number of locales in the Southwest, documentary photographs of petroglyphs and pictographs—some taken as recently as the 1960s or 1970s—have been compared with photographs of the same sites in the 1990s. The contrast is alarming. Rock-art in many places in the Southwest is experiencing impact at an unprecedented rate and intensity.

VANDALISM is foremost in this devastation. Innumerable petroglyphs and pictographs have been marked with paint, scratched and scraped by vehicles and tools, scarred by gunshot, smashed, broken off, overturned, fire-blackened, or willfully damaged in other irreversible ways. Additionally, vandals steal rock-art, often by blasting, chipping, or prying it loose, or they deface sites with their own marks. Geoglyphs are intentionally driven-over by vehicles, disrupting the created designs as well as the fragile surrounding desert surface.

OTHER HUMAN ACTIVITIES, some committed by people who have no intention of causing harm, have also had damaging effects. Abrasion, erosion, and tumbled rock have resulted from admiring visitors climbing across sites for closer views and photography. Indelible marks have been left during efforts to brighten or clean rock-art for improved viewing. Tenacious residues from projects to make rubbings, molds, and castings of petroglyphs have defaced and weakened the rock. Inadvertent damage has also been caused by the presence of livestock; by modifications to water drainage; by activities that surround mining; and by the reconfiguration of the landscape for roads, buildings, dams, and other construction projects.

NATURAL FORCES certainly affect rock-art, as well. Changes in a rock-art site may be caused by sandstorms and dust storms, rain, snow, the freezing and thawing of ice, seeping water, floods, the dissolution and crystallization of soluble salts, earthquakes, landslides, natural fires, tree branches, plant roots, lichen, algae, moss, bacteria, and even sunlight. These forces shift rocks from their earlier positions, erode surfaces, fade colors, and alter the appearance of rock on a large and a small scale— sometimes gradually, sometimes suddenly.

ROCK-ART CANNOT BE PLACED IN MUSEUMS or other secure areas to protect it from people's carelessness and the elements of nature. In most cases, access to it cannot be completely controlled or monitored. Hence, the involvement of individuals is critically important to the protection of sites. Every individual who has contact with rock-art—hikers, rock climbers, sightseers, campers, picnickers, rangers, photographers, construction crews, artists, ranchers, archaeologists, and seekers of spiritual connection—can learn about, practice, and publicly model careful and appropriate behavior at rock-art sites and persuade others to do the same (see **Visitor Guidelines**, pages 86–95).

MORE WILL BE LEARNED in coming years. Today, we look back with regret at many of the actions of previous generations at rock-art sites—just as future generations will surely criticize some of our present-day practices. One guiding principle is sure to remain central, however: the best approach to rock-art protection is the anticipation and prevention of damage. Once damage has occurred, it is difficult and costly to undo— often, it is impossible. Therefore, we must focus on what is known to be damaging and commit ourselves to avoiding it.

ROCK-ART PROTECTION occurs with every careful footstep, every act of self-restraint, and every instance of teaching and role-modeling. Just as the

growth of participants in outdoor recreation has meant educating every-
one involved about the importance of reducing impact so that the nat-
ural environment could be protected, so people can be made conscious
of the value of avoiding impact to rock-art—and can be shown how to
accomplish it.

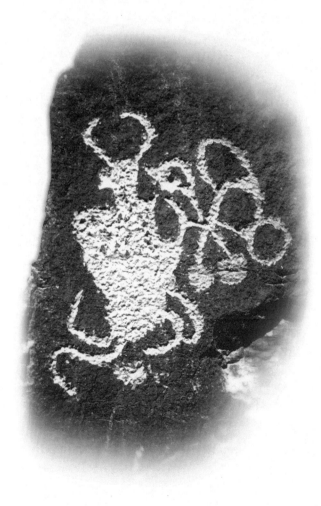

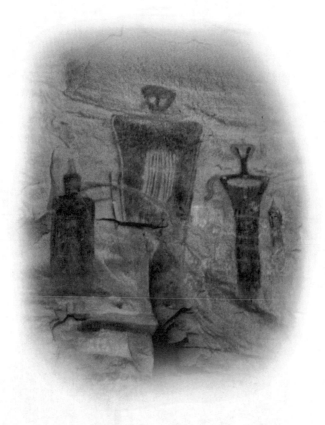

Visiting Rock-Art Sites

MOST OF US BALK AT LIMITATIONS on our freedom in the outdoors. However, many important aspects of rock-art site "etiquette" are not self-evident or obvious, and the reasons behind some familiar rules are not well understood. To clarify this situation, explanations and other details are offered along with each guideline listed below. The more knowledgeable you become about the many facets and subtleties of rock-art site protection, the more effective you will be in explaining their importance to others—and in keeping your own impact to a minimum.

These recommendations incorporate guidelines published by several important organizations in Southwestern rock-art protection: URARA–The Utah Rock-Art Research Association ("Rock-Art Site Etiquette"); the Coconino National Forest–Sedona Ranger District ("Archaeological Site Etiquette Guide"); the Sacred Sites International Foundation ("Guidelines for Visiting Sacred Sites"); and the National Outdoor Leadership School, the Bureau of Land Management, and the National Park Service ("ARPA: Cultural Site Etiquette").

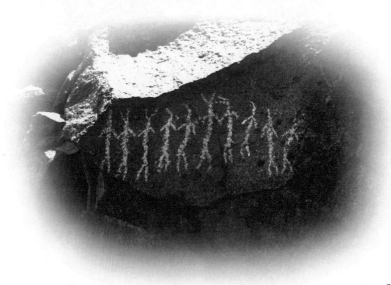

Visitor Guidelines

GET INFORMED

◎ Before you go, learn about the rock-art you will be visiting from books or Web sites. Remember, however, that not everything you read is up-to-date or accurate!

◎ Stop at the visitor center and ask for information.

◎ Chat with rangers or site volunteers; they often possess a wealth of information and are happy to share it.

OBTAIN PERMISSION TO VISIT THE SITE

◎ Sites on Indian reservations or private land, and sites that have special caretakers, may not be freely accessible to the general public. Do not trespass to view rock-art sites, and do not violate the sanctity of sites where those in charge have prohibited visitors.

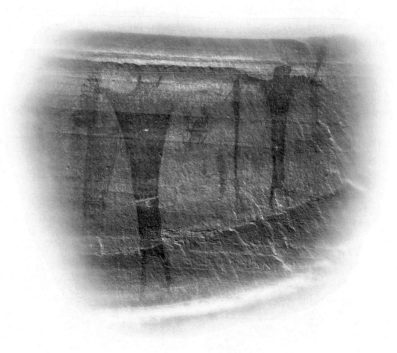

BE SENSITIVE TO THE SITE'S SPIRITUAL AND HISTORICAL IMPORTANCE

◎ Many rock-art sites have religious importance in Native American cultures. Act as you would if you were a guest at someone else's church, temple, mosque, or other place of prayer and spiritual significance.

◎ Regardless of your sincerity, if you are an "outsider," it may not be appropriate for you to leave offerings at a rock-art site. Ritual activities may require special instruction or preparation, and some offerings may be inappropriate at certain sites or may need purification.

◎ Be aware that present-day Native American groups may have cultural affiliation with a site. This may be true whether or not there is a direct ancestral line from the rock-art makers to the modern group. Native American tribes and communities often trace historical and cultural connections differently than academically trained historians.

MINIMIZE THE NUMBER OF VEHICLES

◎ If you are in a group, carpool to reduce the number of vehicles going to the site. Vehicles are noisy, and they erode surfaces, raise dust, and contribute deposits from exhaust.

◎ Stay on existing roads—do not "pioneer" vehicle trails or parking areas. This is a basic tenet of minimum-impact backcountry activity.

KEEP DOGS UNDER CONTROL

◎ Dogs must be prevented from digging, defecating, or urinating at rock-art sites.

◎ Dogs must be prevented from disturbing wildlife and wildlife habitats at rock-art sites.

BEFORE APPROACHING A SITE, IDENTIFY AREAS TO AVOID

◎ Plan ahead to avoid the damage that accompanies the "Oops!" syndrome. Before proceeding to the site, identify existing trails, try to spot archaeological remains, and take note of any fragile or unstable areas at the site that should not be walked upon.

CONSIDER VIEWING THE SITE FROM A DISTANCE

◎ Archaeologists are increasingly studying the subtle evidence of prehistoric human activity around rock-art sites. Minimizing your activities that could disrupt that evidence will make future research more fruitful.

◎ Keeping to a distance of even 10 or 15 feet from the rock-art significantly reduces trampling and other impact.

◎ Use binoculars or the telephoto lens of a camera to see "up close."

IF A TRAIL EXISTS, STAY ON IT

◎ Trampled ground surface reduces the natural beauty of the area and promotes erosion.

◎ Fragile desert plants, soil crusts, and animal habitat can easily be damaged by foot traffic.

◎ Subtle cultural features of sites can be damaged by foot traffic; don't enlarge the extent of this type of impact.

◎ At sacred sites, trails will keep you from walking on areas that may be difficult for you to recognize as inappropriate for foot traffic.

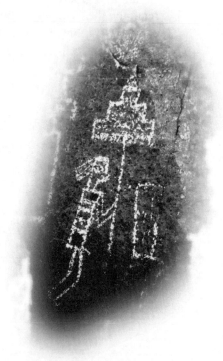

DO NOT ALTER, MOVE, OR REMOVE ANYTHING—NATURAL OR CULTURAL

◎ Rock-art sites encompass much more than the "marks" involved in the petroglyphs and pictographs—the surrounding rock features and plants, the effects of animal activities, and changes from erosion and weathering are all potentially meaningful components of the site.

◎ Do not disturb stones or other material in cracks, slots, or gaps in the stones at rock-art sites. They may be part of the site's arrangement or history, placed there by those who made or used the rock-art.

◎ Never dig into the ground at a rock-art site, and prevent dogs from doing so.

◎ Movable artifacts—even fragmentary pieces of pottery, bone, shell, and worked stone—are significant to archaeologists and other researchers. Do not collect, move, hide, or interfere with artifacts you observe. Once they have been taken out of context, you will find that such souvenirs offer very little pleasure. Look at them where you find them, then leave them there.

◎ Features associated with a rock-art site, such as arranged rocks, fire pits, debris from making stone tools, and trash piles, provide invaluable information to researchers. Do not disturb them.

◎ Do not add marks to rock-art, and do not alter or obliterate "disturbing" or "indecent" images. Doing so is vandalism—even if your motives are not malicious.

◎ The collection of modern trash is an exception to the "remove nothing" rule. Because the presence of litter encourages further littering, gathering and removing recently discarded trash (generally, packaging from food and drink, fruit skins and cores, cigarette butts, and tissue paper) is a positive contribution to the site's well-being.

OBSERVE AND RECORD ROCK-ART ONLY BY VIEWING, SKETCHING, AND PHOTOGRAPHING

◉ Never "highlight" rock-art. Up to the recent past, site visitors (including researchers) sometimes emphasized rock-art designs by marking over them with such materials as chalk, charcoal, crayon, paint, or metallic powders. However, it is now universally acknowledged that this practice is destructive. Experience has shown that these materials are far more difficult to remove than anticipated, interfere with dating techniques, and can accelerate the deterioration of the original rock-art markings. Furthermore, they rarely add anything to a viewer's appreciation or understanding of the original rock-art. No materials of any kind should be applied to rock-art to improve its visibility. However, never clean off highlighting materials when you find them on rock-art—this is a job for a professional, which necessitates very careful assessment, and special materials and procedures (see **Conservators: Specialists in Rock-Art Care,** page 103). Report your findings to the land manager, or to a vandalism hotline.

◉ Never "refresh" or "brighten" petroglyph marks by pecking in the design areas, rubbing them to expose fresh rock, or incising them with tools. Doing so irreversibly damages the original work, interferes with dating techniques, and invariably results in defacement.

◉ Never wet pictographs. Water and other liquids will dissolve soluble materials in the rock and paint, and as the liquid evaporates, it will pull these dissolved materials up to the surface where they remain as a scum or haze. The appearance and longevity of the rock-art is almost certain to be affected, invariably for the worse.

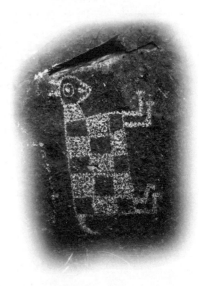

◎ Never make rubbings, tracings, castings, or impressions of rock-art. No recording methods should be used that involve putting foreign substances on or near the rock-art or that involve pressing against it with hands or tools. The making of a tracing or rubbing applies pressure that can crumble or fracture petroglyph edges, and the process often results in the rubbing ink or crayon marking the stone. Tape or other adhesives used to hold the paper or cloth against the stone can pull off rock when removed and sometimes leave stains. Castings with silicone, latex, paper pulp, or other materials involve liquids that seep into the rock; these introduced materials can stain, and they also can weaken the rock and speed its disintegration. Castings invariably leave trapped bits of material in the interstices of the rock.

NEVER CLEAN ROCK-ART

◎ If you find graffiti at a rock-art site, never attempt to remove it. Cleaning rock-art necessitates professional assessment and the use of carefully selected materials and procedures (see **Conservators: Specialists in Rock-Art Care**, page 103). Report your findings to the land manager or to a vandalism hotline.

◎ Leave all natural accretions—such as bird droppings and plant secretions—undisturbed. Efforts to clean them away may harm the rock-art.

◎ Leave lichen, moss, and other such growths on rock-art undisturbed. Although some experts regard these growths as harmful, others do not. Cleaning techniques—if removal has been determined to be necessary—involve special materials and procedures to avoid damage to the rock-art.

◎ Do not blow or brush dust off of pictographs. In doing so, you may damage or disrupt loose, powdery, or flaking paint.

ADD NOTHING TO THE ROCK-ART SITE

◉ Some site visitors experience a desire to "join" rock-art makers from the past by adding their own work to a site. The lack of barriers between the site and the surrounding natural setting may encourage this impulse. However, creating modern rock-art is never acceptable at a rock-art site, and on public lands, doing so is punishable by law.

◉ Rearranging the landscape—such as by creating rock rings, rock piles, or other features—disturbs the integrity of the site.

◉ Never leave remnants of your activities at a rock-art site: pack out your discards. In the arid Southwest, even organic materials—including orange peels, apple cores, cigarette butts, and tissue paper—take years, if not decades, to biodegrade.

DO NOT TOUCH ROCK-ART

◉ Very little is gained from touching rock-art directly—but the risks are considerable and the effects may be irreversible. As in a museum or sculpture garden, "touch with your eyes, not with your hands."

◉ Touching can smudge pictographs and disintegrate paint layers.

◉ Oils, salts, acids, bacteria, fungi, and dirt on hands can be transferred to rock-art, leading to disfigurement and deterioration. Many effects are not immediately apparent.

◉ Frequent touching can gradually erode and stain rock-art.

DO NOT CLIMB AT A ROCK-ART SITE

◉ Do not climb into or over rock-art. Foot traffic abrades rock very noticeably in a short time, and it tends to cause rock tumbling and other shifts. Rock-art markings themselves are also eroded by being walked upon.

◉ Do not disturb rocks in chimneys, slots, or gaps in the stones at rock-art sites; even though it may not be obvious, these may be an integral part of the site.

◉ Do not hike or climb above rock-art panels. The stability of the rock is not always possible to determine, and you could cause crumbling, fracture, or breakage.

SAVOR YOUR VISIT

- ◎ Immerse your senses in the site. Quietly experience the larger setting: the plants, wildlife, water, sky, sounds, and smells.

- ◎ Proceed slowly so as to appreciate the character of each instance of rock-art; don't race through an area. At each place you stop, take notice of the rock-art's context and surroundings, as well as the rock-art designs themselves. See also **Enlarging Your View,** page 29.

- ◎ Resist interpreting, categorizing, or otherwise pigeonholing what you see.

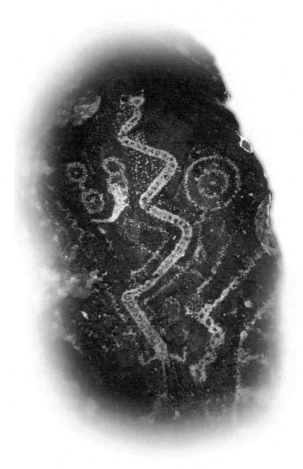

CAMP AWAY FROM ROCK-ART SITES

◎ Ground-sleeping, eating, cooking, and other camping activities leave traces that will interfere with archaeological interpretation of the area.

◎ Camping almost inevitably leads to crushing of vegetation, disruption of the ground surface, and other changes. These hard-to-avoid consequences should not be allowed to impact rock-art sites.

◎ Human excrement should not be left near rock-art sites, and dogs should not be allowed to urinate or defecate at rock-art sites.

NO BURNING AT ROCK-ART SITES

◎ Do not smoke, light candles or incense, or "smudge" using burning plant materials at rock-art sites. Smoke accumulates on rock-art, discolors it, and interferes with dating.

◎ Fire danger is usually high in the Southwest because of the dry climate, and an accident at a rock-art site that leads to a fire can cause severe and irreversible damage.

◎ Build campfires at least a quarter of a mile away from sites. Smoke, charcoal, high heat, and other remains from a fire can affect the archaeological record and efforts to date the site. The heat from campfires can affect the stability of rock and cause it to disintegrate more easily.

HELP OTHERS BECOME INFORMED

◎ Help convince others at rock-art sites to understand and accept these guidelines. If you visit rock-art with others, it may be worthwhile to discuss site etiquette beforehand.

◎ Take responsibility for children, whose self-restraint and understanding of the importance of site etiquette may be minimal.

HELP SITE MANAGERS

◎ Follow the rules of the landowner or site manager if they are more restrictive than the guidelines listed above. Those closely involved in the long-term care of a site are often acutely aware of special vulnerabilities or sensitivities that need to be taken into consideration.

◎ If you become aware of problems at a rock-art site—vandalism, garbage, damaged barriers, or any other troubling impacts—promptly inform those responsible for protecting the site. This may be a tribal office, a city or state archaeologist, a forest ranger, a park ranger, a government agency, or even a private landowner. If you do not know where to call for the specific site, call a vandalism hotline. See **Reporting Vandalism,** pages 98–101.

◎ Consider volunteering to assist land managers in educational outreach, site monitoring, site recording, or other organized activities that help protect rock-art sites.

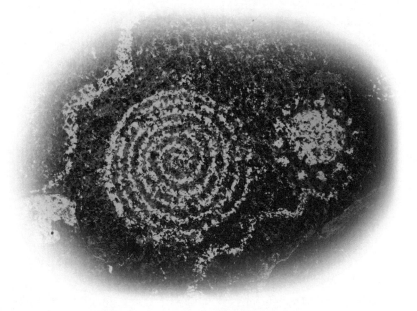

Photography

ROCK-ART PHOTOGRAPHY is not always easy. In the Southwest, glaring sunlight can wash out subtle distinctions in color and relief. Rocks with a glossy surface (such as basalt with thick rock varnish) or with glittery constituents (such as sandstone) may reflect distractingly bright spots of light. Dark shadows across part of a sunlit petroglyph site can make it impossible to record overall views. Raking light may distort the appearance of designs.

Lighting isn't the only problem. Rock-art may be high on a cliff, leading to foreshortening and other distortions when photographed from below. Lichen or moss may cover designs. Rock varnish may have worn away, making the color distinction between petroglyphs and their background virtually nonexistent. Weathering may have left pictographs very faint and pale.

At times, it will be impossible to obtain the photographs you want.

TIPS FOR BETTER ROCK-ART PHOTOS

◎ Before leaving home, check your camera batteries. If you can't check them, bring extras. In the hot Southwest, batteries tend to run down quickly—and some types are difficult or impossible to obtain in small towns and rural areas.

◎ Bring plenty of film. If you enjoy photographing rock-art, the cost of a few more rolls of film will seem like nothing when you get home. Running out at the site can be maddening. If you use a special type (such as slide film or black-and-white film), stock up ahead of time. These less-common types of film are some-times difficult or impossible to obtain in the field.

◎ Have dust and rain protection for your equipment—the site may be windy, and showers can develop quickly.

◎ Have a polarizing filter available. It can substantially reduce glare in your pictures.

◎ Have a telephoto lens available—200 mm, if possible. Telephoto lenses eliminate one of the most stubborn temptations at a rock-art site: to trample over the site simply to get close enough for the right picture.

◎ Have a wide-angle lens available—28 mm is good. It will enable you to photograph the full extent of a rock-art panel or group of designs. You will also be able to capture, in one frame, the amaz-ingly long rock-art designs made in many parts of the Southwest, which sometimes extend for many feet across the rock surface.

◎ Have a zoom lens available. Some photographers feel that a 28–85 mm zoom lens makes a great all-purpose lens for rock-art photography. This one lens will enable you to make immediate adjustments for many kinds of rock-art photos without the nui-sance of changing lenses at the site.

- Take pictures when the sky is light but the sun is not visible in the sky. Dawn and dusk are favorite times for some rock-art photographers. If you know the topography, you may be able to plan for a time when the sun is behind a cliff or other landscape feature. Cloudy days are wonderful for rock-art photography.

- If you cannot arrange to visit at a time of indirect sunlight, plan to create some shade. Bring along a large, opaque sheet of cloth (or even an accordion-type or spring-loaded windshield shade), which a companion can hold so as to eliminate glare or uneven lighting around your subject. A caution: This works only for relatively small sections of rock.

- Take photos that show rock-art in its setting—the entire boulder, rock wall, or panel—as well as close-up photos showing individual marks and designs. After you've left the site, you will probably find that shots showing the broader context will help convey the impact of the individual designs.

- Never compromise rock-art preservation and site protection measures in an effort to capture a picture. See **Visitor Guidelines,** pages 86–95.

- Never compromise personal safety in an effort to capture a picture.

- If photography is impossible because the lighting is terrible, rain is streaking the rock surface, or your camera is on the fritz, change your agenda. Find other ways to savor and remember the site; don't let an inability to take good pictures spoil your visit.

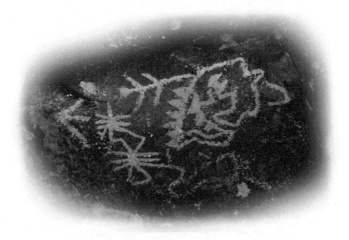

Reporting Vandalism

VANDALISM TO ROCK-ART is a persistent and destructive reality. The explosive settlement of the Southwest is bringing tens of thousands of new residents every year into areas that have been—at most—lightly occupied since the beginning of time. Unfortunately, with increased numbers comes increased frequency of vandalism.

IF YOU ENCOUNTER VANDALISM IN PROGRESS, *do not approach wrong-doers directly.* Instead, discreetly make observations (written, if possible), and convey the information to authorities promptly. Note such things as the exact location of the site; the time of day; the nature of the vandals' activities; descriptions of the individuals involved; and the vandals' vehicle makes, colors, and license plate numbers. Take photographs only if you can do so undetected. Remember that vandals may be armed or belligerent—do not confront them or in any way jeopardize your personal safety. Report what you saw as promptly as possible.

IF YOU DISCOVER THAT VANDALISM HAS OCCURRED, *do not collect evidence or clean up the mess.* Make a written and (if possible) a photographic record of pertinent details. Note such things as the exact location of the site; the date and time of day; the nature of the vandalism; and any disturbances, trash, tire marks, footprints, or other signs you observe at the scene that may be related to the act of vandalism. As much as possible, however, stay away from vandals' traces, particularly if the evidence is fresh—your efforts to be helpful and thorough may disturb or destroy evidence that law enforcement officers need for prosecution. Report what you saw as promptly as possible.

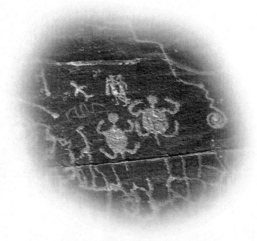

REPORT VANDALISM to on-site authorities whenever possible. If you are at a site with a visitor center or ranger station, their personnel will know what action should be taken. If the site is not staffed, contact the land manager or law enforcement agency, or call a vandalism hotline.

Most rock-art sites in the Southwest are not "manned," and you may not even know which governmental agency or authority has jurisdiction over the site. *Don't let this prevent you from following through with a report.* Listed below are phone numbers of offices that will receive your information and forward it to the appropriate law enforcement agency.

For Public Lands Nationwide
(800) 722-3998

This toll-free number connects you to the law enforcement division of the BLM (U.S. Department of the Interior, Bureau of Land Management) in Salt Lake City, Utah. Originally established to facilitate enforcement of ARPA (the Archaeological Resources Protection Act of 1979), *this number currently serves as a clearinghouse for reports of vandalism on public lands nationwide,* as well as for reports of destruction or theft of cultural or natural resources on government property. If the locale involved is not within the BLM's jurisdiction, your report will be forwarded to the appropriate law-enforcement agency. If you call during non-business hours, you may reach a message machine. In your message, be sure to leave complete information about how you can be contacted, along with your report.

Arizona
(800) VANDALS

This toll-free hotline—answered 24-hours-a-day, 7-days-a-week—connects you to the Arizona Game and Fish Department. They have been designated to receive calls about vandalism to archaeological sites in Arizona, including rock-art. They will dispatch law-enforcement personnel and/or forward your report to the appropriate agency.

Colorado
(303) 866-3395

This phone number will connect you with the State Archaeologist in the Office of Archaeological and Historic Preservation at the Colorado Historical Society. This office will act on reports of vandalism to archaeological sites in Colorado or will forward your report to the appropriate agency. If you call during non-business

hours, you may reach a message machine. In your message, be sure to leave complete information about how you can be contacted, along with your report.

Nevada
(775) 684-3444

This phone number will connect you to Nevada's State Historic Preservation Office (SHPO). This office will act on reports of vandalism to archaeological sites in Nevada or will help determine the appropriate agency. If you call during non-business hours, you may reach a message machine. In your message, be sure to leave complete information about how you can be contacted, along with your report.

New Mexico
(505) 827-3989

This number will connect you with the State Archaeologist's office at New Mexico's Historic Preservation Division, in Santa Fe. The email address is gdean@oca.state.nm.us and the fax number is (505) 827-6338. This office will act on reports of vandalism to archaeological sites in New Mexico or will forward your report to the appropriate agency. If you call during non-business hours, you may reach a message machine. In your message, be sure to leave complete information about how you can be contacted, along with your report.

Utah
(800) 722-3998

This toll-free number connects you to the law enforcement division of the BLM (U.S. Department of the Interior, Bureau of Land Management) in Salt Lake City. Although this number also serves as a clearinghouse for reports of vandalism on public lands nationwide, it is the best starting point to report rock-art site vandalism in Utah. If the locale involved is not within the BLM's jurisdiction, your report will be forwarded to the appropriate law-enforcement agency. If you call during non-business hours, you may reach a message machine. In your message, be sure to leave complete information about how you can be contacted, along with your report.

TWO FEDERAL LAWS are of paramount importance in the protection of rock-art and rock-art sites in the Southwest. In 1906, the U.S. Congress passed The Antiquities Act, and in 1979, it passed the Archaeological Resources Protection Act (ARPA). These laws make it a federal crime to

remove, damage, or deface rock-art on federal or Indian lands, or to excavate without proper permission. ARPA provides for very stiff penalties, as well as for a reward for information that leads to a conviction.

The full text of these laws is available online or in the *United States Code (U.S.C.)*:

The Antiquities Act
The American Antiquities Act of 1906
16 *U.S.C.* 431–433
http://www.cr.nps.gov/local-law/anti1906.htm

ARPA (often pronounced as a word: *Ar'-puh*)
The Archaeological Resources Protection Act of 1979
16 *U.S.C.* 470 aa–mm
http://www2.cr.nps.gov/laws/archprotect.htm

STATES, COUNTIES, AND CITIES throughout the Southwest have also enacted laws to protect antiquities on the lands they own and manage. Private landowners, too, have played a significant role in protecting petroglyph and pictograph sites.

ADDITIONAL INFORMATION about laws that protect rock-art sites can be found on a Web site sponsored by the National Park Service, *Links to the Past*. This site includes a page that offers easy connections to full-text versions of additional federal laws, regulations, standards and guidelines, and executive orders related to cultural resources.

Links to the Past "Laws, Regulations, Standards, and Conventions Related to Cultural Resources"
http://www.cr.nps.gov/linklaws.htm

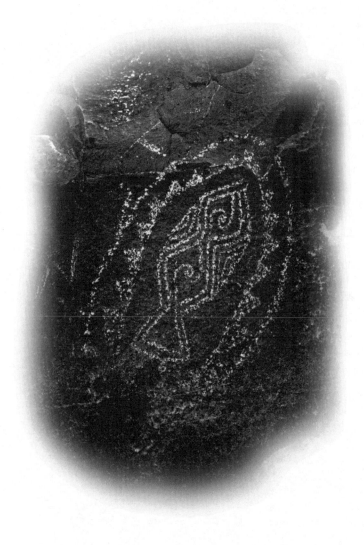

Conservators: Specialists in Rock-Art Care

CONSERVATORS ARE EXPERTS in the physical characteristics of artifacts and in scientific approaches to protecting, cleaning, and repairing them. All professionals involved in rock-art care place an emphasis on the *prevention* of problems, but when damage does occur to rock-art—whether from a single act (such as vandalism) or from an ongoing agent of deterioration (such as water seepage)—conservators are knowledgeable about effective and appropriate ways to respond.

Rock-art conservators know how to remove painted graffiti from pictographs and petroglyphs in such a way that solvents and paint do not leave harmful residues and stains in the base rock. They know the best methods and materials to use in disguising damage scars on pictographs and petroglyphs. And they know how to research the causes of rock-art deterioration and recommend what is necessary to keep it from continuing.

Conservators are also knowledgeable about the history of caring for rock-art. They know which methods and materials have withstood the test of time—and which have not.

SITE MANAGERS AND CONSERVATORS who protect and repair rock-art also consider many issues beyond the physical well-being of the petroglyphs and pictographs. Their work must respect the needs and concerns of Native Americans, archaeologists, historians, date-assessment specialists, and all others who place value on particular aspects of a site—needs and concerns that may not be immediately obvious.

Modern rock-art conservation is guided by an ideal to interfere as little as possible with the original work and to protect all attributes of the work known to be of value or potential value. It is important to recognize that a professional conservator brings a high level of expertise to problems in rock-art care. In many cases, treatments carried out without this expertise—sometimes done in an effort to take action quickly or cheaply—have caused further damage and have created additional and more complex problems.

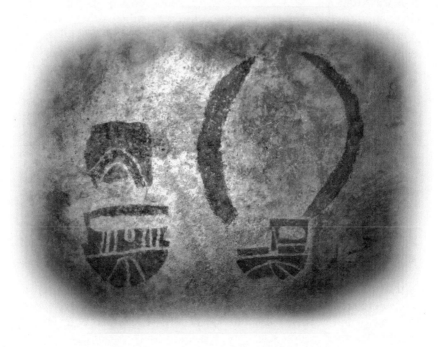

Native Americans' Concerns

NATIVE AMERICANS THROUGHOUT THE SOUTHWEST emphasize the importance of protecting rock-art from damage, desecration, and destruction. In some instances, rock-art sites are still in active use in religious and cultural life. In other cases, sites may be revered as special or sacred, even if they do not have a central role in present-day religious activities.

WILLIAM WEAKHEE (Five Sandoval Indian Pueblos Executive Director in 1997) spoke against a controversial plan to create a road through the Petroglyph National Monument site near Albuquerque, New Mexico, as follows:

> Our religion depends upon the existence and preservation of sacred sites. We have already lost so many of these sites. I ask you to open your hearts and minds to our cultural and religious obligation and our duty to provide spiritual guidance for future generations as our ancestors have done for us. The religious importance of this area is not limited to the petroglyphs themselves. Messages to the spirit world are communicated throughout the entire volcanic escarpment, with the petroglyphs being one form of communication to the third world. Our medicine people who are trained and our clan people who are trained to use these methods of communication are the ones who come to the area to talk to the world beneath.

> —*Statement before the U.S. Senate Committee on Energy and Natural Resources, October 23, 1997; quoted in* Voices from a Sacred Place, *Verne Huser (ed.), 1998.*

HERMAN AGOYO (All-Indian Pueblo Council Chairman in 1988) spoke about the significance of rock-art within Petroglyph National Monument to present-day Native American people:

> To us, these petroglyphs are not the remnants of some long lost civilization that has been dead for many years ... they are part of our

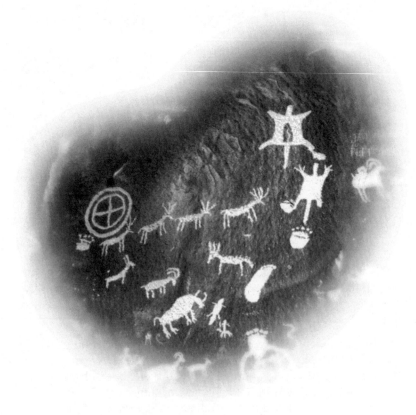

living culture. What is stored in the petroglyphs is not written in any book or to be found in any library. We need to return to them to remind us of who we are and where we came from, and to teach our sons and daughters of it.

—Statement made to the U.S. House of Representatives Committee on Interior and Insular Affairs, Albuquerque, New Mexico, October 11, 1988; quoted in Voices from a Sacred Place, *Verne Huser (ed.), 1998.*

IN DISCUSSING ROCK-ART SITE PRESERVATION, some Native Americans emphasize that these sites are, above all, the heritage of Native Americans. Only secondarily, they say, should rock-art sites be seen as resources for archaeologists wishing to reconstruct the past or as components of the general U.S. national heritage. Native American concerns may not necessarily conflict with these other interests—but, it is argued, the values and interests of Native Americans should not be ignored or

regarded as unimportant, as has often occurred in situations involving Native American cultural heritage.

MODERN NATIVE AMERICANS SOMETIMES CLAIM CULTURAL OR SPIRITUAL CONNECTIONS to rock-art that was made many centuries or even millennia in the past—often before people of their tribe or linguistic group were even present in the region near the rock-art. Many people wonder how such a connection can exist. In some instances, historians and archaeologists tell us that the rock-art was made so long ago that no one can guess exactly who the descendants of the makers really are. The answer to this puzzle is found by understanding that histories and cultural connections can legitimately be traced in different ways. Although a historian using academic methodology may have concluded that the descendants of the people who made rock-art in a certain area are not known, a Native American elder or tribal historian may know of long-recognized linkages going back many generations. And these two views are not necessarily contradictory—they are simply different ways of relating to the past.

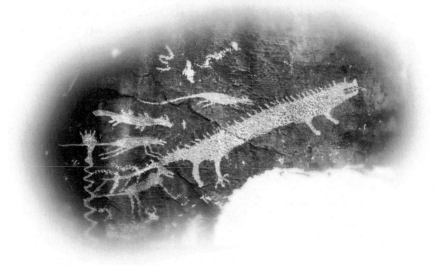

Selected Southwestern Rock-Art Sites

Arizona

California

Colorado

Nevada

New Mexico

Texas

Utah

Site List

ARIZONA
1. Deer Valley Rock Art Center
2. Homolovi Ruins State Park
3. Painted Rocks Petroglyph Site
4. Palatki
5. South Mountain Park
6. V-Bar-V Petroglyph Site

CALIFORNIA
7. Anza-Borrego Desert State Park
8. Blythe Intaglios
9. Chumash Painted Cave State Historic Park
10. Little Petroglyph Canyon

COLORADO
11. Mesa Verde National Park

NEVADA
12. Grapevine Canyon
13. Redrock Canyon National Conservation Area
14. Valley of Fire State Park

NEW MEXICO
15. Bandelier National Monument
16. Chaco Culture National Historic Park
17. El Morro National Monument
18. Petroglyph National Monument
19. Three Rivers State Park

TEXAS
20. Hueco Tanks State Historical Park
21. Seminole Canyon State Historical Park

UTAH
22. Canyonlands National Park
23. Capitol Reef National Park
24. Colorado River Rock-Art Sites
25. Fremont Indian State Park
26. Newspaper Rock State Historical Monument
27. Nine Mile Canyon
28. Sand Island and Butler Wash Petroglyph Sites

Selected Southwestern Rock-Art Sites

THROUGHOUT THE SOUTHWEST, there is growing awareness of rock-art's vulnerability. Vandalism is one concern—but so is the cumulative effect of large numbers of enthusiastic visitors "loving sites to death."

In the interest of site protection and preservation, many land managers currently recommend that a rock-art locale not be promoted as a visitor destination until the site has been thoroughly documented and recorded, a site management plan has been established, and the site's condition is being monitored regularly.

THE SITES LISTED IN THIS SECTION meet those three conditions and, with a few carefully chosen exceptions, all are in state or federal parks or monuments where the level of monitoring is high. The places listed in this directory also meet several conditions of importance to visitors: They contain impressive rock-art, they are publicly accessible (although a few require advance arrangements), and access does not normally require a special vehicle. Remember that this list represents only a tiny sample of the Southwest's wealth of Native American rock-art.

BEFORE YOUR VISIT TO ANY SITE, we encourage you to

- ◎ Confirm that the site will be accessible at the time you plan to visit (access rules are changing in many areas)
- ◎ Inquire about fees, hours, and visitor restrictions
- ◎ Verify that your vehicle is suitable for local road conditions
- ◎ Determine whether visitor amenities (water, food, gas, telephone, etc.) will be available
- ◎ Check bookstores, the library, and the Internet for maps and background information on the area's history and archaeology

ABOVE ALL, PLEASE REMEMBER: Wherever you encounter rock-art—whether at a monitored site (such as those listed below) or in the backcountry—always observe the **Visitor Guidelines** discussed on pages 86–95.

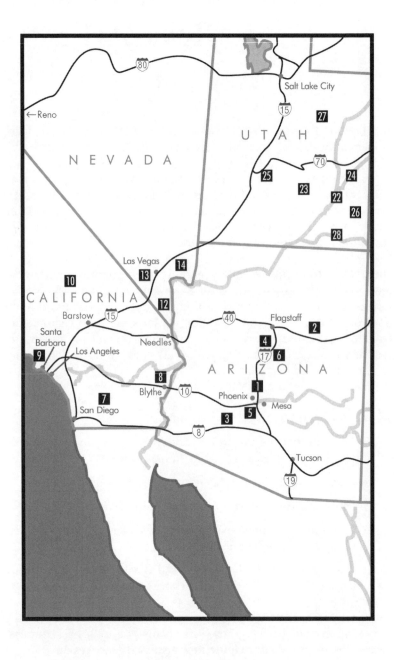

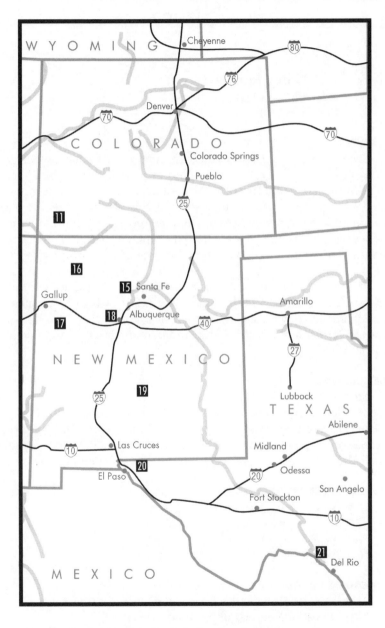

Numbers correspond to the list of rock-art sites on pages 114–141.

Arizona

1. Deer Valley Rock Art Center
Hedgpeth Hills Petroglyph Site
Phoenix, Arizona

FEATURES

The Deer Valley Rock Art Center is located at the Hedgpeth Hills petroglyph site—the largest concentration of petroglyphs in the Phoenix area. More than 1,500 Hohokam, Patayan, and Archaic petroglyphs can be seen on 500 basalt boulders along the Skunk Creek drainage. Although it is not permissible to climb among the boulders, hundreds of petroglyphs are easily visible from the trail. The best times to visit are morning and late afternoon, when the glare of the sun interferes less with viewing.

The visitor center has exhibits and videos that introduce visitors to the site and to rock-art of the region. The facility, which is operated by Arizona State University's Department of Anthropology, also houses a research center and research library (appointments are necessary to use the library).

GETTING THERE

From central Phoenix, take Interstate 17 north about 15 miles to the Deer Valley Road exit and go west about 2.5 miles. Look for the Rock Art Center's sign on your right after crossing 35th Avenue. The main concentration of petroglyphs is at the end of an easy 0.25-mile walking trail. The trail is wheelchair accessible and has water and shade.

CONTACT INFORMATION

Deer Valley Rock Art Center
3711 W. Deer Valley Road
Phoenix, AZ 85308
(623) 582-8007

ADDITIONAL INFORMATION

Arizona State University's Deer Valley Rock Art Center
http://www.asu.edu/clas/anthropology/dvrac

2. Homolovi Ruins State Park
near Winslow, Arizona

FEATURES

Located alongside the Little Colorado River, *Homolovi* is a Hopi word meaning "place of the little hills." The principal prehistoric remains at Homolovi are four pueblos that were occupied between AD 1200 and 1425 by ancestors of the Hopi people. The largest pueblo had 1,000 rooms. Many of the rock-art images at Homolovi depict *katsinas*, spirit beings significant in Hopi religion. Flute players and other anthropomorphs are also portrayed.

GETTING THERE

The park is 5 miles northeast of Winslow on State Route 87. Several rock-art sites are located in the park—check at the visitor center for directions to currently accessible sites.

CONTACT INFORMATION

Homolovi Ruins State Park
HCR 63, Box 5
SR-87 North
Winslow, AZ 86047-9402
(520) 289-4106

ADDITIONAL INFORMATION

Homolovi Ruins State Park
http://www.pr.state.az.us/parkhtml/homolovi.html

3. Painted Rocks Petroglyph Site
near Gila Bend, Arizona

FEATURES

The Painted Rocks Petroglyph Site is approximately 90 miles southwest of Phoenix. It is a small rocky outcrop almost entirely covered with geometric, curvilinear, and figurative petroglyphs in Archaic and Hohokam styles. Although it is now under the Bureau of Land Management (BLM), the site was part of the Arizona State Park system until 1989 and its locale is still shown on many maps as Painted Rocks State Park.

GETTING THERE

Take Interstate 8 to Painted Rock Dam Road (Exit 102) about 12.5 miles west of Gila Bend. Go north about 11 miles to Rocky Point Road (unpaved). Painted Rocks Petroglyph Site is about a 0.5 mile west of Painted Rock Dam Road on Rocky Point Road. A parking area is adjacent to the site.

CONTACT INFORMATION

Bureau of Land Management
Phoenix Field Office
2015 W. Deer Valley Road
Phoenix, AZ 85027
(602) 580-5500

ADDITIONAL INFORMATION

Bureau of Land Management (BLM) Phoenix Field Office (includes map)
http://phoenix.az.blm.gov/paint.htm

4. Palatki
near Sedona, Arizona

FEATURES

The rock-art at Palatki includes Archaic-, Sinagua-, and Yavapai-style petroglyphs and pictographs. In several rock shelters west of the visitor center, the overhanging rock has shielded the wall from the weather, preserving pictographs in white, red, yellow, and black—including a few polychrome designs. Non-representational designs (rakes, squiggles, and dot patterns) and anthropomorphic figures in red are attributed to the Archaic period, from 3,000 to 6,000 years ago. Yellow animal and human representations are believed to have been made by Sinagua people who lived in the neighboring pueblos. The large circular "shield" designs, in the alcove and on the cliff wall above the pueblo, are also believed to be of Sinagua origin. Charcoal drawings, some depicting riders on horses, were done in the historic period by Yavapai or Apache peoples. There are also vertical scratches in some areas that some researchers believe predate even the Archaic drawings.

GETTING THERE

Travel south from Sedona on US 89A. About 0.5 mile south of mile marker 365, at a group of mailboxes, turn right onto a dirt road (Forest

Road 525 to Forest Road 795; passable for all cars when dry), and drive 8 miles to Palatki and the parking area. The trail is an easy walk along the base of the cliff face.

CONTACT INFORMATION
 Coconino National Forest
 Sedona Ranger District Station
 250 Brewer Road
 Sedona, AZ 86339
 (520) 282-4119

ADDITIONAL INFORMATION
 Palatki: 6,000 Years of Arizona Rock Art
 http://aztec.asu.edu/aznha/palatki/palatki.html

5. South Mountain Park
Box Canyon and Pima Canyon
Phoenix, Arizona

FEATURES
 Phoenix's South Mountain Park is the largest city park in the nation—about the size of Manhattan Island. It has been estimated that there are over 10,000 petroglyphs in and around South Mountain Park. Petroglyphs can be seen from a number of access points around the perimeter of the park. Two easily accessible areas are in Box Canyon and Pima Canyon.

Box Canyon
 Box Canyon is very close to the South Mountain Park Visitor Center and offers an excellent area for viewing Hohokam petroglyphs. Many are alongside the trail, while others can be spotted high up on the hillside. Some of the most unusual petroglyphs are long-necked birds, which can be seen on a hill to the left of the trail just as it emerges from the notch.
 From central Phoenix, travel about 7 miles south on Central Avenue to the main entrance to South Mountain Park. Follow the signs to the South Mountain Environmental Education Center, then go to the east end of the large parking lot. Take the Holbert Trail, which goes into Box Canyon through a small gap between two hills. Follow it for about 0.5 mile through the valley, and look for petroglyphs near the trail and on adjacent hills.

Pima Canyon

Pima Canyon is at the eastern end of South Mountain Park. Some of the most interesting petroglyphs in this area are very near the parking lot for the Desert Classic Trail. Less than 0.25 mile from the trail's beginning is a large boulder with numerous Hohokam-style petroglyphs. Also in this area is the Marcos de Niza Rock, thought at one time to have been an inscription made by the 16th-century Spanish explorer (its authenticity is now disputed).

From Phoenix, take Interstate 10 toward Tucson and exit at Baseline Road. Go east on Baseline a short distance to Priest Drive and turn south (left). Take Priest 1 mile south to Guadalupe and turn east (right). Follow Guadalupe under the interstate to 48th Street and turn right. Look for Pima Canyon Road almost immediately on the left. The parking area is a short distance at the end of the road.

CONTACT INFORMATION

South Mountain Park
10919 South Central Avenue
Phoenix, AZ 85040
(602) 534-6324

ADDITIONAL INFORMATION

Check in at the South Mountain Park Visitor Center for more detailed directions and guidance. Volunteers from the Pueblo Grande Museum (the city of Phoenix's archaeology museum) periodically give guided tours to other petroglyph sites within South Mountain Park; phone (602) 495-0901 for information.

6. V-Bar-V Petroglyph Site
near the Village of Oak Creek, Arizona

FEATURES

V-Bar-V is one of the most outstanding sites for viewing Sinagua-style petroglyphs. Until recently on private property, V-Bar-V is now part of the Coconino National Forest. The site consists of dozens of individual glyphs distributed over several large panels along Wet Beaver Creek. Numerous petroglyphs have small cupules pecked into the rock near their centers. On the main panel, practically every figurative element contains one of these small circular depressions. Although these cupules seem to have been made subsequent to the creation of the original petroglyphs, they are believed to have been made in ancient times.

Beaver Creek supported a number of significant pueblos during the period between AD 1300 and 1400, including the sites known today as Montezuma Castle and Montezuma Well. The pueblo associated with these petroglyphs occupied a nearby hilltop.

GETTING THERE

From Interstate 17 take the Sedona exit (Exit 298, State Highway 179), then turn right toward the Beaver Creek Ranger Station. Follow this paved road approximately 3 miles. Immediately after the bridge over Beaver Creek, look for the entrance to the site on your right. The site itself is approximately 0.5 mile from the parking lot on a well-maintained trail. V-Bar-V was part of an early experiment in fee-based site management. Fees collected at this site are used to fund local site management and development. Call ahead for information on hours the site is open.

CONTACT INFORMATION

Coconino National Forest
Sedona Ranger District Station
250 Brewer Road
Sedona, AZ 86339
(520) 282-4119

ADDITIONAL INFORMATION

"V-Bar-V Brochure," by Peter Pilles, Archaeologist, Coconino National Forest
http://aztec.asu.edu/aznha/vbarv/vvbroch.html

California

7. Anza-Borrego Desert State Park
Borrego Springs, California

FEATURES

Anza-Borrego Desert State Park contains excellent examples of southern California desert pictographs associated with the Kumeyaay and Diegue'o people. At some sites, pigments have faded over the centuries, but in many rock shelters, colors and designs remain vivid and clear. This is a particularly attractive place to visit in the spring when wildflowers are in bloom.

GETTING THERE

To get to the Anza-Borrego Desert State Park Visitor Center, turn north (left) off State Highway 78 onto Highway S3, drive about 6 miles, and turn left onto Borrego Springs Road. Continue to Christmas Circle in the town of Borrego Springs. Drive around the circle to Palm Canyon Drive West. Drive about 3 miles and follow the signs to the visitor center. Look for the American flag—the visitor center is built into a hill, so it is mostly underground.

From the parking area, continue about 0.75 mile to a large rounded boulder on the right side of the canyon—look for red and yellow pictographs. Ask at the visitor center for directions to other pictographs in the park.

CONTACT INFORMATION

Anza-Borrego Desert State Park
200 Palm Canyon Drive
Borrego Springs, CA 92004
(760) 767-5311

ADDITIONAL INFORMATION

Anza-Borrego Desert State Park
http://www.anzaborrego.statepark.org/park.html

Anza-Borrego Desert Natural History Association
http://www.california-desert.org/start_main.html

8. Blythe Intaglios
near Blythe, California

FEATURES

Six gigantic geoglyphs on the floor of the desert can be viewed at three locations near Blythe, California. The largest figure measures 171 feet in length. These intaglio designs date to at least 450 years ago—and they may be more than 2,000 years old. According to the Mohave and Quechan people of the lower Colorado River area, the human-like figure seen at each of the three sites represents Mastamho, the creator of Earth and life. The animal figure shown at two of the sites represents Hatakulya, one of two mountain lion beings who helped in Earth's creation. In ancient times, ceremonial dances were held in the area. The sites are open 24 hours per day, year-round.

GETTING THERE

The sites are approximately 15 miles north of Blythe, California, off State Route 95. Two of the site areas are reached by an easy hike of less than 0.25 mile; the third site area requires a 0.5-mile hike, part of it up a 10% grade.

CONTACT INFORMATION

BLM Yuma Field Office
2555 E. Gila Ridge Road
Yuma, AZ 85365
(520) 317-3200
fax: (520) 317-3250

ADDITIONAL INFORMATION

Bureau of Land Management (BLM) Yuma Field Office
http://yuma.az.blm.gov/intaglios.html

9. Chumash Painted Cave State Historic Park
near Santa Barbara, California

FEATURES

Because of their extremely fragile nature, the locations of most Chumash pictograph sites are not publicized. Painted Cave, north of Santa Barbara, is one of the few that is openly accessible—and it is an especially complex and fascinating site. Chumash religious leaders are believed to have made the paintings in this sandstone cave to influence

supernatural beings to intervene in human affairs. The pictographs include religious imagery, as well as elements interpreted as likenesses of fishermen. Charcoal pigment from a black disk design in the cave has been dated to the late 1600s. Analysis of styles and superpositioning indicate that other figures were painted both before and after that date. The opening to the cave is currently protected by an iron grate, but the designs can be seen with the aid of a flashlight. Site managers request that photographic flashes not be used. The Painted Cave site is open from dawn to dusk and there is no admission charge.

GETTING THERE

Take Highway 154 northwest out of Santa Barbara for about 5 miles and turn right on Painted Caves Road, which is 3 miles south of the San Marcos Pass. About 2 miles up this steep, narrow road (not suitable for trailers and RVs), look for the cave on the left just as you drop into a shady canyon. There is a small parking pullout.

CONTACT INFORMATION

California State Parks
Channel Coast District Headquarters
1933 Cliff Drive, Suite 27
Santa Barbara, CA 93109
(805) 899-1400
(805) 968-3294

ADDITIONAL INFORMATION

California State Parks
http://parks.ca.gov/south/channel/cpcshp525.htm

10. Little Petroglyph Canyon
near Ridgecrest, California

FEATURES

Southern California's Coso Range contains some of the most remarkable rock-art in North America. Tens of thousands of petroglyphs cover boulders and canyon walls for long stretches along streams that drain into China Lake and Airport Lake. In many places, the rock-art designs overlap and vary in size and style, indicating that these sites were in use over a long period of time—probably thousands of years. Coso rock-art is distinctive for its bighorn sheep designs, for human-like figures with decorated heads and patterned bodies, and for depictions

of "pouches" with long handles. Many experts believe that much of this rock-art was created as part of shamanism.

GETTING THERE

Since World War II, the Coso Range rock-art sites have been within the United States Naval Air Weapons Station. The Maturango Museum in nearby Ridgecrest (on U.S. Highway 395, north of San Bernardino) offers tours (by advance reservation) most weekends in the spring and fall. One of the most popular tour destinations is the spectacular Little Petroglyph Canyon (also called Renegade Canyon). Tours usually depart first thing in the morning, so stay in Ridgecrest the night before and plan on a full day for the trip. Participants caravan in their vehicles through the military facility, then climb to the high tableland capped by basalt. Although a good part of the drive is on dirt roads, they are well maintained and passable by most vehicles.

The hike from the parking area to the beginning of Little Petroglyph Canyon is less than 0.5 mile. From there, you can follow the canyon downstream for a little more than a mile. The canyon bottom is sandy in some places, and some boulder-scrambling is necessary, so the going can be slow. The main reason that this mile-long walk can take hours, though, is that there are thousands of petroglyphs on hundreds of panels to stop and appreciate. Bring plenty of film.

CONTACT INFORMATION

Maturango Museum
100 E. Las Flores Ave.
Ridgecrest, CA 93555
(619) 375-6900

ADDITIONAL INFORMATION

Maturango Museum Home Page
(look for Petroglyph Tours information)
http://www1.ridgecrest.ca.us/~matmus/default.html

Photos from Little Petroglyph Canyon
http://www.ridgecrest.ca.us/~matmus/Petpics.html

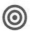

Colorado

11. Mesa Verde National Park
near Cortez, Colorado

FEATURES

The largest group of petroglyphs at Mesa Verde National Park are seen on Petroglyph Point Trail, a 2.3-mile trail that begins near the museum on Chapin Mesa. In Step House, petroglyphs can be seen on a boulder and, elsewhere in the park, there are a few other isolated markings.

GETTING THERE

Mesa Verde National Park is entered off U.S. 160, east of Cortez, Colorado.

CONTACT INFORMATION

Mesa Verde National Park
PO Box 8
Mesa Verde National Park, Colorado 81330
(970) 529-4465

ADDITIONAL INFORMATION

Mesa Verde National Park
http://www.nps.gov/meve/

Nevada

12. Grapevine Canyon
near Laughlin, Nevada

FEATURES

Grapevine Canyon contains the largest concentration of petroglyphs in southern Nevada. The canyon is at the base Spirit Mountain, of one of the most sacred areas for the Yuman peoples of the Colorado River Valley, and the rock-art is associated with prehistoric Yuman peoples who lived and farmed along the Lower Colorado River.

In February 2000, a large slab of rock with petroglyphs on it broke loose and tumbled down the hillside in Grapevine Canyon. This natural rockfall is a reminder to use caution around cliff faces while exploring rock-art.

GETTING THERE

From Laughlin, Nevada, travel about 5 miles northwest on State Route 163 to Christmas Tree Pass. Turn right (north) and go about 2 miles to a dirt road, which ends in a parking area after about 0.25 mile. The petroglyphs are located in a rocky canyon west of the parking area. This is a popular area for picnickers as well as for those who appreciate rock-art. The site is free and is open year-round. Note: Grapevine Canyon can be extremely hot in the summer months.

CONTACT INFORMATION

Lake Mead National Recreation Area
601 Nevada Highway
Boulder City, NV 89005
(702) 293-8907

ADDITIONAL INFORMATION

Laughlin, Nevada, Chamber of Commerce
http://www.laughlinchamber.com/attractions.htm

13. Red Rock Canyon National Conservation Area
near Las Vegas, Nevada

FEATURES

One of the best-known rock-art areas in Nevada is about 17 miles west of Las Vegas. There are several sites in Red Rock Canyon—check in at the visitor center for orientation and information on site access.

GETTING THERE

From Las Vegas, take Charleston Boulevard west to the Red Rock Canyon Visitor Center.

CONTACT INFORMATION

Red Rock Canyon National Conservation Area
HCR 33, Box 5500
Las Vegas, NV 89124
(702) 363-1921

ADDITIONAL INFORMATION

Bureau of Land Management, Las Vegas Field Office
http://www.redrockcanyon.blm.gov/introduction.htm

BLM Red Rock Canyon Web Site
http://www.nv.blm.gov/vegas/redrock/red3.htm

14. Valley of Fire State Park
near Overton, Nevada

FEATURES

In addition to being a spectacular geological region with beautiful red-rock formations, this part of southern Nevada also supported the westernmost Anasazi communities. There is evidence of occupation from the Anasazi Basketmaker period through the mid-1200s. Several Anasazi petroglyph sites in Valley of Fire State Park are open to the public.

The Atlatl Rock Site is named for the portrayal of an atlatl (a spear- or dart-thrower) and its long dart. Other designs at the site include anthropomorphs, quadrupeds, and geometric elements. The presence of the atlatl suggests that the site predates AD 500, at which time bows and arrows displaced atlatls and darts in this region. The Mouse Tank Site has several petroglyph panels along a 0.25-mile trail.

GETTING THERE

Valley of Fire State Park is about 50 miles northeast of Las Vegas. From Interstate 15, exit on State Route 169 east to the state park and Overton (exit 75 from the south, exit 93 from the north). Follow this good gravel road to the visitor center. The Atlatl Rock and Mouse Tank sites are a short distance from the visitor center. The hike to each site is less than 0.5 mile.

CONTACT INFORMATION

Valley of Fire State Park
P.O. Box 515
Overton, NV 89040
(702) 397-2088

ADDITIONAL INFORMATION

The Lost City Museum of Archaeology in Overton presents a great deal of material relating to the Anasazi occupation of this area: 721 S. Moapa Valley Blvd., P.O. Box 807, Overton, NV 89040; (702) 397-2193.

Valley of Fire State Park Virtual Visitor Center
http://www.desertusa.com/nvval/index.html

New Mexico

15. Bandelier National Monument
near Los Alamos, New Mexico

FEATURES

The rock-art at Bandelier is plentiful and distinctive. Much of it can be seen in direct association with the room blocks of large pueblos. The cliffs of Bandelier are formed of volcanic tuff, a light colored and relatively soft rock, and much of the rock-art is found near rooms that were excavated into the cliff walls.

Tsankawi is a separate section of Bandelier National Monument, 11 miles north of the Frijoles Canyon area. Petroglyphs can be seen around

the base of the mesa and associated with rooms dug into the cliff wall. Many petroglyphs were made on the smoke-blackened walls inside small caves.

Some sites at Bandelier continue to be important religious shrines for contemporary people of the neighboring pueblos. The peoples of Santa Clara, San Ildefonso, and Cochiti pueblos trace their ancestry to sites within Bandelier National Monument.

GETTING THERE

Bandelier National Monument is 46 miles west of Santa Fe, New Mexico, near Los Alamos. From Santa Fe, take U.S. 285 to Pojoaque, then go west on State Highway 502 and south on State Highway 4.

The Frijoles Canyon cliff dwellings (talus houses) are within a short, easy walk of the visitor center along a 1.5-mile paved trail. It leads though the Tyuonyi Pueblo ruins, which are within 400 yards of the visitor center. A guidebook describing each of the stops along the trail is available.

At Tsankawi, you can take a 2-mile self-guiding loop trail that leads from the highway through the ruin. Parts of the trail follow an ancient path, and in some places the old trail has been worn into the soft volcanic rock to a depth of nearly two feet.

CONTACT INFORMATION

Bandelier National Monument
HCR 1, Box 1, Suite 15
Los Alamos, NM 87544
(505) 672-0343

ADDITIONAL INFORMATION

Bandelier National Monument
http://www.nps.gov/band/

16. Chaco Culture National Historic Park
northwestern New Mexico

FEATURES

The people who inhabited Chaco Canyon from AD 900 to 1150 are renowned for the massive architecture of their settlements and their highly developed communication systems. The Chaco region also contains intriguing rock-art. Petroglyphs can be seen on the canyon walls throughout the area. Pictographs near Peñasco Blanco have been inter-

preted to depict the supernova that appeared in July 1054. Located on a overhanging rock roof-high above the canyon, the elements include a crescent moon, a 10-pointed star, a handprint, and a sun sign. Nearby is a design said by some to represent the appearance in AD 1066 of Halley's Comet.

GETTING THERE

The recommended access route to the park is from the north via Highway 44/550. Turn off Highway 44/550 at County Road 7900—3 miles southeast of Nageezi and approximately 50 miles west of Cuba (at mile 112.5). This route is clearly signed from Highway 44/550 to the park boundary (21 miles). The route includes 5 paved miles (CR 7900) and 16 miles of unpaved road (CR 7950/7985).

From the south (Interstate 40, at Thoreau, exit 53), turn north on New Mexico 371 and proceed to Crownpoint. Four miles north of Crownpoint, turn right on Navajo 9. Continue east on Navajo 9 for 36 miles to the marked turnoff in the community of Pueblo Pintado. Turn north on Navajo 46 for 10 miles (unpaved). Turn left on County Road 7900 for 15 miles (unpaved). Turn left on County Road 7950 and follow the signs 16 miles (unpaved) to the park entrance.

Although these roads are generally maintained, they can become impassable during bad weather. Call the park for current road conditions.

Several trails lead you to rock-art in the park. A short trail begins at the visitor center and winds behind Una Vida Pueblo. A longer trail of about 2 miles begins at the west end of the canyon and leads to Peñasco Blanco along an old wagon road down Chaco Wash. The cliff face on the north of the road contains a rich collection of rock-art and historic inscriptions. At the end of this trail is the "supernova" pictograph. Ask at the visitor center for directions to other publicly accessible rock-art.

CONTACT INFORMATION

Chaco Culture National Historical Park
P.O. Box 220
Nageezi, NM 87037
(505) 786-7014

ADDITIONAL INFORMATION

Chaco Culture National Historic Park
http://www.nps.gov/chcu/

17. El Morro National Monument
near Ramah, New Mexico

FEATURES

El Morro, a sandstone bluff with a permanent water source at its base, has long served as a desert landmark for Native Americans, Spaniards, and Anglos. Many Anasazi petroglyphs can be seen at El Morro, but the site is now best known for its historic inscriptions. Although El Morro was first noted in Spanish records in 1583, the earliest dated inscription was made April 16, 1605, when the first Spanish governor of New Mexico, Don Juan de Oñate, led an expedition through the region. There are also inscriptions from Americans, including Army officers and travelers.

GETTING THERE

From Interstate 40 at Grants, New Mexico, take State Highway 53 west 42 miles, past El Malpais National Monument to the El Morro National Monument turnoff.

From Gallup, take State Highway 602 south 32 miles to State Highway 53 west for 24 miles to the El Morro National Monument turnoff.

An easy, 0.5-mile, self-guided trail leads to the pool and inscriptions. A 2-mile hike leads to the top of the bluff and the remains of the 800-room pueblo built in the 13th Century.

CONTACT INFORMATION

El Morro National Monument
Route 2, Box 43
Ramah, NM 87321
(505) 783-4226

ADDITIONAL INFORMATION

El Morro National Monument
http://www.nps.gov/elmo/

18. Petroglyph National Monument
Albuquerque, New Mexico

FEATURES

More than 20,000 prehistoric and historic Native American and Hispanic petroglyphs are protected along 17 miles of Albuquerque's

West Mesa escarpment. Most of the petroglyphs were created between AD 1300 and 1650 and represent the Rio Grande rock-art style. This is the only federal park or monument set aside for the specific purpose of protecting Native American petroglyphs and making them accessible to the public. The sites remain important in the religious traditions of present-day Native American peoples of the Rio Grande Valley.

Petroglyphs include many figurative elements, including animals, birds, and detailed human figures, some shown in active poses. Figures are often depicted with garments and headdresses and may be holding various objects.

GETTING THERE

From Albuquerque, take Interstate 40 west to Unser Boulevard. Go north 3 miles to the Monument Visitor Center; go 5 miles north to the Boca Negra Unit.

There are self-guiding trails through petroglyph areas at Boca Negra. The trails near the visitor center in Rinconada Canyon and other petroglyph areas in park lead to several petroglyph concentrations; plan to visit several of these areas.

CONTACT INFORMATION

Petroglyph National Monument
6001 Unser Boulevard NW
Albuquerque, NM 87120
(505) 899-0205

ADDITIONAL INFORMATION

Petroglyph National Monument
http://www.nps.gov/petr/

19. Three Rivers State Park
Near Carrizozo, New Mexico

FEATURES

More than 21,000 individual petroglyphs have been counted at the Three Rivers petroglyph site. This remarkable concentration of rock-art can be seen on boulders and outcrops along a low ridge more than a mile long. The petroglyphs are attributed to the Jornada Mogollon people who lived in the area between AD 900 and 1400. You can spend an hour at this site and see hundreds of glyphs—or you can spend a couple of days and still feel that there is more to see. Many of the petro-

glyph designs have the recognizable features of humans, insects, plants, birds, fish, reptiles, and other animals.

GETTING THERE

From Tularosa, go north 17 miles on U.S. Highway 54 to Three Rivers. From Carrizozo, go south 28 miles to Three Rivers. From Three Rivers, go east 5 miles on County Road B30 (paved), and follow the signs to the site.

There is a 1-mile interpretive trail from which you can view literally thousands of petroglyphs created over a period of a few hundred years. Trail markers correspond to a trail guide indicating petroglyphs of particular interest. There is also an interpretative trail to the remains of a Mogollon village in the valley below.

CONTACT INFORMATION

Caballo Resources Area
Bureau of Land Management
1800 Marquess
Las Cruces, NM 88005
(505) 525-4300

Texas

20. Hueco Tanks State Historical Park
near El Paso, Texas

FEATURES

Some of the best-preserved and most distinctive Southwestern pictographs can be seen in the caves and shelters of Hueco Tanks State Historical Park. At this locale, the weathering of an igneous dome resulted in numerous hollows (*huecos* in Spanish) and caves in the rock. In some of these caves, pictographs of Archaic, Jornada, and Apache styles were created during the thousands of years of human activity in the area. The Archaic pictographs involve curvilinear and geometric designs. The Jornada-style paintings are the most prominent elements at Hueco

Tanks, including elaborately decorated faces (masks) with horns. Apache-style pictographs, which date from the historic period, depict people in Western-style clothing, as well as horses, cattle, and buildings.

In addition to the attraction of its unique rock-art, Hueco Tanks is a rock-climbing mecca. The heavy impact of visitors has led to restrictions on access to parts of the park. Since 1998, only the North Mountain section of the park is open to visitors unaccompanied by a guide, and no more than 50 unguided people will be allowed in the North Mountain area at a time. A maximum of 210 visitors will be allowed in the park at any one time.

However, on regularly scheduled tours for rock-art viewing, guides take visitors to various other areas of the park (primarily East Mountain, East Spur, and West Mountain). Contact the park for details on tour dates, times, and availability.

GETTING THERE
From El Paso, take U.S. 62/180 east approximately 32 miles to Ranch Road 2775.

CONTACT INFORMATION
Hueco Tanks State Historical Park
6900 Hueco Tanks Road No. 1
El Paso, TX 79938
(915) 857-1135

ADDITIONAL INFORMATION
Hueco Tanks State Historical Park
http://www.tpwd.state.tx.us/park/hueco/hueco.htm

21. Seminole Canyon State Historical Park
near Comstock, Texas

FEATURES
The rock shelters of the Lower Pecos River contain some of the most spectacular rock-art in the Southwest. Complex polychrome paintings suggest ceremonial activities. The rock-art record in the region begins about 2000 BC and extends into the historic era. The extra time and planning required to visit Panther Cave (accessible by boat) or Presa Canyon is well worth the effort. The pictographs in this large rock shelter support an interpretation of elaborate shamanistic practices in the late Archaic period.

GETTING THERE

The park is 9 miles west of Comstock on U.S. Highway 90, just east of the Pecos River Bridge. Tours to the Fate Bell Shelter, involving a moderate hike, are conducted twice daily Wednesday through Sunday. Tours to Panther Cave, Presa Canyon, and other special locales should be arranged in advance. Call the park for tour fee information and availability.

CONTACT INFORMATION

Seminole Canyon State Historical Park
P.O. Box 820
Comstock, TX 78837
(915) 292-4464
(800) 792-1112

ADDITIONAL INFORMATION

Seminole Canyon State Historical Park
http://www.tpwd.state.tx.us/park/seminole/seminole.htm

Utah

22. Canyonlands National Park
southeastern Utah

FEATURES

For those prepared to hike, the rock-art of Canyonlands National Park is some of the most remarkable in the Southwest. From the Barrier Canyon-style rock-art in Horseshoe Canyon and the Maze District to polychrome Basketmaker pictographs, there are wonderfully preserved sites tucked into canyons and rock shelters throughout the park.

The Great Gallery of Horseshoe Canyon is the best-known and—relatively speaking—the most easily accessible component of Canyonlands National Park rock-art. Other sites within the park include the so-called All-American Man and pictographs that are thought to depict human trophy heads. For information on access and directions

to specific sites, check with the visitor center for the Maze and Needles units of the park.

GETTING THERE
There are several entry points for Canyonlands National Park. Call the park offices for specific information, road conditions, and permit information. Backcountry permits are required for overnight use and are limited in number; reservations are recommended.

CONTACT INFORMATION
Canyonlands National Park
2282 S. West Resource Blvd.
Moab, UT 84532-3298
(435) 719-2313

ADDITIONAL INFORMATION
Canyonlands National Park Home Page
http://www.nps.gov/cany/

Great Gallery, Canyonlands National Park
http://www.nauticom.net/users/ata/greatgallery.html

Cowboy Camp Rock Art, Canyonlands National Park
http://www.westworld.com/~woody/cowboy.html

Anasazi Rock Art, Needles District, Canyonlands National Park
http://www.westworld.com/~woody/anaz-art.html

23. Capitol Reef National Park
near Torrey, Utah

FEATURES
The Petroglyph Pullout Trail near the Capitol Reef National Monument Visitor Center leads to a number of Fremont-style petroglyph panels. At the end of the path is a particularly striking mountain sheep petroglyph and a large anthropomorph. For information about other rock-art in the park, including specific directions to sites that are open to the public, inquire at the visitor center.

GETTING THERE
Capitol Reef National Park is in south-central Utah. From the east on Interstate 70, take Highway 24 (Exit 147) south and west through Hanksville. From the west on Interstate 70, take Highway 24 (Exit 48)

south and east through the communities of Loa, Lyman, Bicknell, and Torrey. The Petroglyph Pullout Trail is on Highway 24, 1.5 miles east of the Visitor Center. A 0.1-mile hike along the base of the cliff takes you past numerous petroglyphs.

CONTACT INFORMATION
Capitol Reef National Park
HC 70 Box 15
Torrey, UT 84775
(435) 425-3791

ADDITIONAL INFORMATION
Capitol Reef National Park
http://www.nps.gov/care/

Capitol Reef National Park: Petroglyph Pullout and
Fremont Indians
http://www.nps.gov/care/petpull.htm

24. Colorado River Rock-Art Sites
near Moab, Utah

FEATURES
Near Moab—a center of outdoor activities in southwestern Utah—rock-art is found in several places. Some of the most accessible are Anasazi petroglyphs along the roads that follow the north and south banks of the Colorado River.

Potash Road/Utah Scenic Byway 279/North Bank of the Colorado
Of particular note along this beautiful road is a large bear petroglyph superimposed on an earlier scene of mountain sheep and hunters.

Kane Creek Blvd./South Bank of the Colorado
Several sites can be seen along Kane Creek Blvd., including Archaic-style and Barrier Canyon-style figures.

GETTING THERE
The Bureau of Land Management and Grand County Travel Council have published a free map and guide to the sites along the Colorado in a brochure titled "Moab Area Rock Art Auto Tour." The brochure's content is also available at the Web site listed below.

For sites on the south side of the Colorado River, take Kane Creek Boulevard west from Main Street in Moab; bearing to the left, follow it until it reaches the river. The first site is at Moon Flower Canyon approximately 2 miles along the river.

For sites on the north side of the Colorado River, take US 191 northwest of Moab to Utah Scenic Byway 279 (also called Potash Road). Follow the signs to INDIAN WRITINGS, the first of which is after about 5 miles.

CONTACT INFORMATION
Moab Information Center
Center and Main
Moab, UT 84532
(435) 259-8825
(800) 635-MOAB (toll free)

The Moab Information Center is a multi-agency facility with interpretative displays, videos, books, maps, and knowledgeable staff.

ADDITIONAL INFORMATION
BLM Moab Area Rock Art Tour
http://www-a.blm.gov/utah/moab/rockart.html

25. Fremont Indian State Park
near Sevier, Utah

FEATURES
Fremont Indian State Park was established after the construction of Interstate 70 through Clear Creek Canyon uncovered the most extensive Fremont occupation site ever encountered. Although the site was largely destroyed by the construction of the road, the visitor center presents a comprehensive overview of Fremont lifeways.

Twelve interpretive trails—including one accessible to wheelchairs—provide diverse opportunities to see a wide range of Fremont rock-art. Petroglyphs predominate at most of the sites, but a short walk from the visitor center to the Cave of the Hands offers a glimpse of painted handprints in a protected rock shelter. Other rock-art sites include Fremont-style anthropomorphs and complex panels that are thought to represent calendars.

GETTING THERE

From Sevier, take Interstate 70 west to exit 17. Follow signs to the visitor center, where books, maps, and detailed directions are available. A fully accessible trail begins at the visitor center and trail markers are accompanied by an interpretive trail guide. Some of the other trails are more difficult.

CONTACT INFORMATION

Fremont Indian State Park
11550 W. Clear Creek Canyon Road
Sevier, UT 84766-9999
(435) 527-4631

ADDITIONAL INFORMATION

Fremont Indian State Park
http://www.infowest.com/fremont/index.html

Max Berthold's Southern Utah: Fremont Indian State Park
http://www.so-utah.com/no89/fremont/homepage.html

26. Newspaper Rock State Historical Monument
near Monticello, Utah

FEATURES

Many states have a rock-art site dubbed Newspaper Rock—typically a heavily marked rock surface that looks as if it could have served as a bulletin board for passersby. In actuality, we do not know how these sites were used, but the notion of a communication center has endured. Utah's Newspaper Rock includes depictions of mounted riders, indicating that at least some of the designs were created in the historic period. The petroglyphs are neatly executed, and their light color against the dark, rock-varnished panel makes them ideal for photography. Most experts attribute these petroglyphs to Ute people, who have occupied the area since the 15th Century, at least.

GETTING THERE

From Monticello, take Highway 191 north about 14 miles to Highway 211. From La Sal Junction, take Highway 191 south about 17 miles. Turn west on 211 toward Canyonlands National Park. Newspaper Rock is approximately 12 miles farther on the right. Continue down this road for the Maze District Visitor Center for Canyonlands National Park.

CONTACT INFORMATION
 Bureau of Land Management
 435 N. Main St.
 P.O. Box 7
 Monticello, UT 84535
 (435) 587-1500

ADDITIONAL INFORMATION
 Max Bertola's Southern Utah: Newspaper Rock State Park
 http://www.so-utah.com/souteast/newspapr/homepage.html

 Newspaper Rock Recreation Site
 http://www.canyonlands-utah.com/pages/newsn.html

27. Nine Mile Canyon
 near Price, Utah

FEATURES

 Nine Mile Canyon is one of the premier concentrations of petroglyphs in the Southwest. Many of the Fremont-style petroglyphs on the canyon walls depict complex scenes and events, including human-like figures that appear to be engaged in religious activities. Plan on dedicating a full day for a trip through Nine Mile Canyon—the road from Wellington, Utah, to the end of petroglyph viewing is approximately 50 miles long, and you will want to make many stops. Before you arrive, acquire a guidebook to help you locate sites.

 Unlike many other rock-art viewing excursions, seeing Nine Mile Canyon is primarily a driving tour, not a hike. Using a guidebook keyed to your vehicle's odometer readings, you will drive along a dirt road, making stops at several dozen points to locate rock-art sites, some of which are 50 to 100 feet above the road.

 Much of the area is private property; remember to respect fences and no-trespassing signs. Traveler amenities in Nine Mile Canyon are very limited—check your gas before leaving Wellington and carry ample water and food.

GETTING THERE

 From Price, take US Highway 6/191 southeast through Wellington. Approximately 7.5 miles beyond Wellington, turn left (north) on 2200 East (also called Soldier Creek Road). Travel 21 miles to the Minnie Maude Creek bridge; about 5 miles later, the first major rock-art sites can be seen.

CONTACT INFORMATION
Price Field Office
Bureau of Land Management
125 South 600 West
Price, UT 84501
(435) 636-3600
or
Vernal Field Office
Bureau of Land Management
170 South 500 East
Vernal, UT 84078
(435) 781-4400

ADDITIONAL INFORMATION
The **Utah Bureau of Land Management**, Price Field Office, has an informative guide through the canyon with odometer readings from site to site, called **In the Canyon of Nine Mile:**
http://www-a.blm.gov/utah/price/inthecanyon.htm

28. Sand Island Petroglyph Site
Butler Wash Petroglyph Site
near Bluff, Utah

FEATURES
The Sand Island Petroglyph Site, on the banks of the San Juan River in southern Utah, offers beautiful examples of Basketmaker and Anasazi rock-art, including a number of prehistoric flute-player designs. The markings here range in age from 800 to 2,500 years old and show a good representation of the rock-art that was made in the San Juan drainage.
At the Butler Wash Site, the large figures are practically "type specimens" of the Basketmaker style. Located at the confluence of Butler Wash and the San Juan River, access is limited to boaters on the river.

GETTING THERE
To visit the Sand Island Site, travel about 4 miles west of Bluff on Highway 153 to the sign for Sand Island. At the bottom of the hill, turn right on the dirt road and go about 0.5 mile to the sign for the site. Parking is within 100 feet of the main Sand Island panel.

To visit the Butler Wash Site, arrange a boat or raft trip with one of the many commercial enterprises that include a stop at the site on their trips down the San Juan.

CONTACT INFORMATION

Bureau of Land Management
435 N. Main St.
P.O. Box 7
Monticello, UT 84535
(435) 587-1500

ADDITIONAL INFORMATION

Max Bertola's Southern Utah: Sand Island Rock Art Site
http://www.so-utah.com/souteast/sandisln/homepage.html

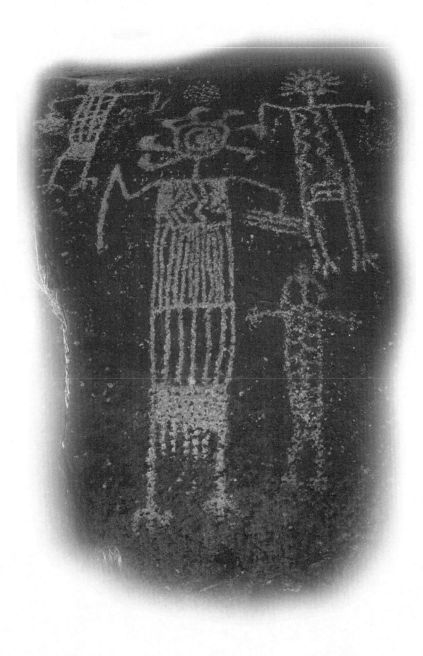

Organizations

AMERICAN ROCK ART RESEARCH ASSOCIATION: ARARA
mailing address:
c/o Arizona State Museum
University of Arizona
Tucson, Arizona 85721-0026
phone: (520) 621-3999
web: http://www.arara.org

The oldest rock-art association in the world, ARARA evolved out of a 1974 symposium in Farmington, New Mexico. The founding members dedicated the organization to the support of rock-art research, conservation, and education. Most members are from the West Coast and Southwest, although the association is concerned with rock-art nationwide. Membership is open to all. ARARA holds an annual meeting (usually over Memorial Day weekend, near noteworthy rock-art sites); awards prizes for research, photography, and conservation; and publishes a series *(American Indian Rock Art)* containing the papers presented at the annual meetings, as well as a quarterly newsletter *(La Pintura)*. ARARA's archives and library are housed at the Deer Valley Rock Art Center (see **Special Resources,** 147–148).

BAY AREA ROCK ART RESEARCH ASSOCIATION: BARARA
mailing address:
c/o Paul Freeman
1959 Webster Street
San Francisco, California 94115
phone: (415) 921-7366 (no answering machine)

Established in 1983, BARARA is an association of rock-art enthusiasts in the San Francisco Bay Area. Membership is open to all. BARARA holds quarterly meetings; publishes a biannual newsletter *(Bay Area Rock Art News)*; organizes visits to rock-art sites; sponsors the BARACEF Fund (to further the preservation of Bay Area and Northern California rock-art sites); and has established the Bay Area Rock Art Archive (see **Special Resources,** page 147).

FRIENDS OF SIERRA ROCK ART: FSRA
mailing address:
P.O. Box 1409
Nevada City, California 95959
phone: (530) 265-2084

FSRA was established to help pro-
vide stewardship for the rock-art of
the Sierra region. Activities include
public education, site monitoring,
rock-art recording, members-only
field trips, meetings, and occasional
newsletters.

INTERNATIONAL FEDERATION OF ROCK ART ORGANIZATIONS: IFRAO
web: http://www.cesmap.it/ifrao/ifrao.html

If you are interested in rock-art groups outside the Southwestern
United States, the IFRAO Web site is an excellent starting point for
learning what's out there. The URLs and other addresses for IFRAO
members will connect you to information about rock-art activities in
other regions all over the world. IFRAO describes itself as a "federation
of national and regional organizations promoting the study of paleoart
and cognitive archaeology." It sponsors (sometimes in conjunction
with other groups) the annual International Rock Art Congress (IRAC).
The IFRAO Web site offers information on *Rock Art Research* (a periodi-
cal published twice a year since 1984) and its other publications. Past
and future rock-art congresses and symposia are reported. IFRAO mem-
bers include:

> American Committee to Advance the Study of Petroglyphs and
> Pictographs (ACASPP)
> American Rock Art Research Association (ARARA)
> Armenian Centre of Prehistoric Art Study
> Associaçao Portuguesa de Arte e Arqueologia Rupestre (APAAR)
> Association des Amis de l'Art Rupestre Saharien (AARS)
> Association pour le Rayonnement de L'Art Pariétal Européen
> (ARAPE)
> Australian Rock Art Research Association (AURA)
> Centar za Istrazuvanje na Karpestata umet nost i Praistorijata na
> Makedonija
> Centro de Investigación de Arte Rupestre del Uruguay (CIARU)
> Centro Studi e Museo d'Arte Preistorica (CeSMAP)

Comite de Investigación del Arte Rupestre de la Sociedad Argentina
de Antropología
East African Rock Art Research Association (EARARA)
Eastern States Rock Art Research Association (ESRARA)
Gesellschaft für Vergleichende Felsbildforschung (GE.FE.BI.)
Groupe de Reflexion sur les Methodes d'Etude l'art Parietal
Paleolithique
Indian Rock Art Research Association (IRA)
Institutum Canarium (IC)
Japan Petrograph Society (JPS)
Mid-America Geographic Foundation, Inc.
Moscow Centre of Rock Art and Bioindication Research
Rock Art Association of Canada, Inc. (RAAC)
Rock Art Association of Manitoba (RAAM)
Rock Art Research Association of China (RARAC)
Rock Art Society of India (RASI)
Sociedad de Investigación del Arte Rupestre de Bolivia (SIARB)
Società Cooperativa Archeologica Le Orme dell'Uomo
Societe Prehistorique Ariege-Pyrenees Sociéte Préhistorique Ariège-
Pyréenées
Southern African Rock Art Research Association (SARARA)
StoneWatch
Verein Anisa

NATIONAL PICTOGRAPHIC SOCIETY: NPS
mailing address:
Carol Patterson, President
2533 West 34th
Denver, Colorado 80211

NPS encourages the use of ethnographic research and contemporary
Native American collaborators in the interpretation of rock-art.
Members receive a newsletter *(National Pictographic Society Newsletter)*.

SOUTHERN NEVADA ROCK ART ENTHUSIASTS: SNRAE
web: http://www.wolsi.com/~urara/snrae/
phone: (702) 897-7878
email: sunray@vegas.infi.net (Nancy Wier)

SNRAE organizes field trips and is involved in site monitoring, rock-
art recording, and conservation projects in southern Nevada. The organ-

ization holds two meetings monthly at the Las Vegas Public Library. Membership is open to all.

UTAH ROCK ART RESEARCH ASSOCIATION: URARA
 mailing address:
 P.O. Box 511324
 Salt Lake City, Utah 84151-1324
 web: http://www.wolsi.com/~urara/

URARA membership is open to all. The organization sponsors field trips, seminars, and a monthly newsletter *(Vestiges)*. Papers given at URARA's annual symposium are published in a series titled *Utah Rock Art*.

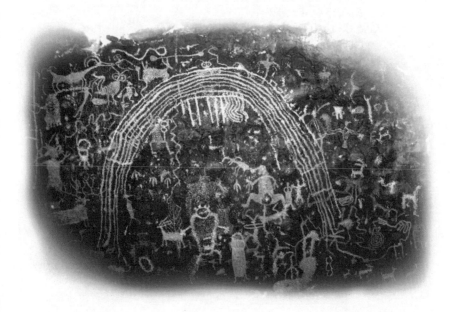

Special Resources

BAY AREA ROCK ART ARCHIVE
mailing address:
Bancroft Library
University of California, Berkeley
Berkeley, California 94720-6000
phone: (510) 642-6481 (Bancroft Library's reference desk)
web: http://www.lib.berkeley.edu/BANC/RockArt/index.html

Established in 1998 by the Bay Area Rock Art Research Association (see **Organizations**, page 143), this archive is a collection of literature and original research that concentrates on the rock-art of California and the West. It includes the Sonin Papers, original research notes by Bill Sonin comprising a rock-art site inventory and bibliography for California. It also includes, as an ongoing project, "Rock Art Studies: A Bibliographic Database" (compiled by M. Leigh Marymor), which in 1999 contained over 7,800 citations. Contact the Bancroft Library beforehand if you are interested in access to the archive.

DEER VALLEY ROCK ART CENTER: DVRAC
location address:
3711 W. Deer Valley Road
Phoenix, Arizona
mailing address:
P.O. Box 41998
Phoenix, Arizona 85080
phone: (623) 582-8007
web: http://www.asu.edu/clas/anthropology/dvrac/

The Deer Valley Rock Art Center is a satellite facility of Arizona State University's Department of Anthropology. Established in 1994 to protect and interpret the adjacent Hedgpeth Hills petroglyph site, DVRAC has a visitor center (including a museum and sales shop) and conducts a variety of educational programs for schools and the general public. The DVRAC also has a rapidly growing research facility; the archives and library of the American Rock Art Research Association (see **Organizations**, page 143) are housed there, along with site records and

147

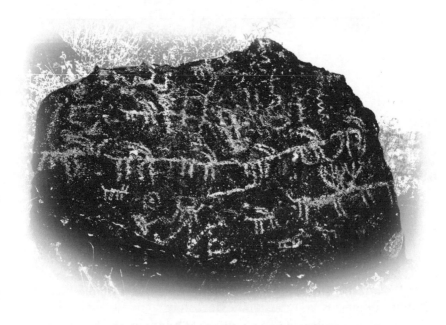

artifacts associated with archaeological projects in north Phoenix.
Archive and library materials are made available to qualified
researchers. Contact the DVRAC beforehand if you are interested in
using these reference materials.

PIEDRA PINTADA BOOKS
 mailing address:
 P.O. Box 1376
 Claremont, California 91711
 phone: (909) 620-6742
 e-mail: books@rock-art.com
 web: http://www.rock-art.com/

 Since 1990, Bob Edberg has operated Piedra Pintada Books, a mail-
order business specializing in publications on all aspects of rock-art—
from scholarly monographs and conference proceedings to
"coffee-table" books. Edberg serves retailers and individual customers
worldwide, deals in both new and used materials, buys collections, and
carries hard-to-find foreign and out-of-print publications.

ROCK ART FOUNDATION, INC.
mailing address:
4833 Fredericksburg Road
San Antonio, Texas 78229-3627
location address:
U.S. Highway 90, between Comstock and Langrey, Texas (northwest of Del Rio), near the Galloway White Shaman Preserve
phone: (210) 525-9907; (888) 762-5278
web: http://www.rockart.org

Established in 1991, the Rock Art Foundation is a nonprofit organization dedicated to the conservation and interpretation of the rock-art of the Lower Pecos region of southwest Texas. Key aspects of its mission include: educating public and private sectors about the endangered status of rock-art in Texas; conducting restoration and preservation research; acquiring endangered sites for transfer to agencies capable of ensuring their integrity; recording sites; fostering harmonious relations with land owners for site management and protection; and archiving photographic collections. The Rock Art Foundation also sponsors field trips and meetings. Membership is open to all.

ROCK-ART LISTSERV
e-mail: rock-art@lists.asu.edu
Established by Peter H. Welsh in 1993 to facilitate discussion of rock-art and rapid dissemination of news and information, this Internet distribution list has about 500 participants all over the world. To subscribe, email <listserv@lists.asu.edu> with exactly the following text (and nothing else) in the message field:
SUBSCRIBE ROCK-ART Firstname Lastname

UCLA ROCK ART ARCHIVE
mailing address:
The Cotsen Institute of Archaeology
A210 Fowler Museum, 151006
University of California, Los Angeles
Los Angeles, California 90095-1510
phone: (310) 825-1720
web: http://www.sscnet.ucla.edu/ioa/labs/rockart/index.html

The UCLA Rock Art Archive is a repository for records and reports on rock-art in California, the Far West, and the Pacific Islands. Housed at the Fowler Museum of Cultural History at UCLA, major collections

include the files of California rock-art scholar and archaeologist Robert F. Heizer; photographic documentation of rock-art in Baja California by writer Harry Crosby; and an extensive collection of site reports, sketches, maps, and photographs documenting sites in Texas, Wyoming, and the Southwest made by architectural historian David Gebhard. The Archive also has ongoing fieldwork, education, and publishing projects. Hours are limited, but special appointments can be arranged by calling or writing beforehand.

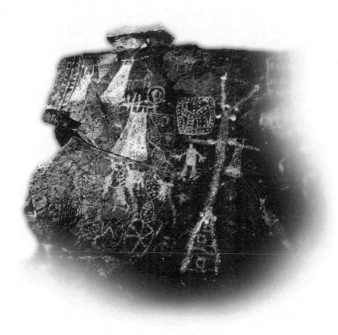

Selected Web Sites

Please note: Web sites for rock-art associations are listed under **Organizations**, 143–145. Web sites pertaining to individual rock-art sites are listed under **Selected Southwestern Rock-Art Sites**, pages 111–141.

ANCIENT HEBREW INSCRIPTION IN NEW MEXICO
web: http://www.unitedisrael.org/loslunas.html

Presented by United Israel, the Los Lunas (New Mexico) decalogue stone is discussed by James D. Tabor; a photograph is included. The information offered at this site is questioned by most authorities, but it presents information on a well known "outlier."

CONSERVATION AND PROTECTION NETWORK
web: http://www.arara.org

Presented by M. Leigh Marymor of ARARA's Conservation and Protection Network Subcommittee, the Conservation and Protection Network presents information concerning site protection and site management, including action alerts, articles, and links to relevant materials.

Connect to ARARA's Web site, then look for the *Conservation Committee* link, which will connect you to the Conservation and Protection Network.

LINKS TO ROCK ART SITES
web: http://www.questorsys.com/rockart/links.htm

Presented by Bob Edberg, owner of Piedra Pintada Books (see **Special Resources,** page 148), this is a useful, well-organized resource with links to a diverse assortment of Web sites pertaining to rock-art worldwide.

PETROGLYPHS AND ROCK PAINTINGS
 web: http://www.execpc.com/~jcampbel/

Presented by John F. Campbell, this site includes many photographs of Southwestern rock-art.

ROCK ART AT RICE
 web: http://www.ruf.rice.edu/~raar/index.html

This Web site was designed as a teaching tool for an undergraduate course at Rice University. It includes sections on dating, interpretative theories, regional styles, conservation, and more. Photos are included. Emphasis is on the U.S. West and Southwest.

ROCK ART GLOSSARY
 web: http://www.geocities.com/Athens/Acropolis/5579/glossary.html

Presented by Kevin L. Callahan, this site lists more than 90 rock-art-related terms and brief definitions, as well as links to rock-art information, with an emphasis on the Upper Midwest.

ROCKARTNET
 web: http://www.rupestre.net/rockart/

Presented by Società Cooperativa Archeologica in Italy, RockArtNet presents *Tracce* (*Tracks*), an online bulletin about rock-art worldwide, and it offers an extensive list of annotated links to rock-art-related sites. The following URLs also contain the RockArtNet lists of links:

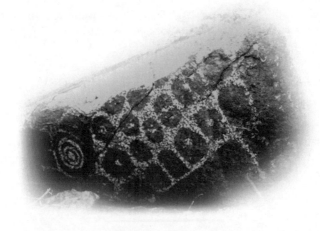

Selected Web Sites

153

http://www.geocities.com/Tokyo/2384/linksa.html#ralin
http://www.geocities.com/Tokyo/2384/links2.html#us
http://www.geocities.com/Tokyo/2384/links.html

ROCK ART OF THE SOUTHWEST
web: http://my.ispchannel.com/~leszekp/rockart/

Presented by a company that sells iron-on petroglyph designs called Transferglyphs, this site contains links to a number of Web sites with pictures of rock-art.

ROCK ART SOLAR MARKERS; THE SOLMAR PROJECT
web: http://www.azstarnet.com/~solmar/

Presented by John Fountain, the SOLMAR Project is developing a database of information on sunlight interacting in distinctive ways with petroglyphs.

SOME ARCHAEOLOGICAL OUTLIERS
web: http://economics.sbs.ohio-state.edu/jhm/arch/outliers.html

Presented by J. Huston McCulloch, this Web page contains links to illustrations and information on the Bat Creek stone, the Grave Creek stone, the Los Lunas (New Mexico) decalogue stone, the Newark (Ohio) decalogue stone and keystone, and other petroglyph and engraved-rock evidence that calls into question the mainstream beliefs about the pre-history of North America.

SOUTHWESTERN UNITED STATES ROCK ART GALLERY
web: http://net.indra.com/~dheyser/index.html

Presented by Doak Heyser, this site includes photographs of Southwestern rock-art.

YAHOO!'S DIRECTORY OF ROCK ART SITES
web: http://dir.yahoo.com/Social_Science/Anthropology_and_
Archaeology/Archaeology/Rock_Art/

Presented by Yahoo!, this is a listing of assorted sites that deal with rock-art, some of which are pertinent to study of the Southwest.

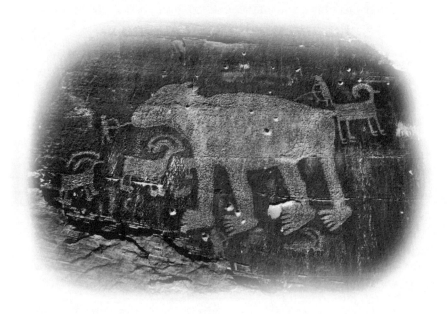

Illustration Notes

Frontispiece. Newspaper Rock State Historical Monument petroglyph panel (detail), Monticello, Utah. Petroglyphs at Newspaper Rock include designs from the 18th and 19th Centuries, made by Ute people (including the bison and horse-mounted hunter seen here). Newspaper Rock is a vertical sandstone rock face with a dark layer of rock varnish.

p. vii. Three Rivers State Park, New Mexico. This Jornada Style pecked petroglyph shows a six-fingered hand. Attention to detail is characteristic of this style.

p. 2. Three Rivers State Park, New Mexico. Note the line extending from the head of this zoomorphic petroglyph.

p. 4. Three Rivers State Park, New Mexico. The Three Rivers site consists of thousands of petroglyphs placed on hundreds of boulders scattered along a low ridge.

p. 6. Three Rivers State Park, New Mexico. At many petroglyph sites, designs overlap.

p. 8. Three Rivers State Park, New Mexico. The filled body is produced by light overall pecking.

p. 9. Central Utah. This red and black painted figure is characteristic of the Barrier Canyon Style. The figure has been damaged by gunshot.

p. 12. Three Rivers State Park, New Mexico. The linear character of the peck marks on this petroglyph suggest that it was made by indirect percussion.

p. 13. Three Rivers State Park, New Mexico.

p. 14. Colorado River Rock-Art Sites, near Moab, Utah. This pecked petroglyph resembles painted Barrier Canyon Style pictographs.

p. 16 (top). Three Rivers State Park, New Mexico. Note the apparently unfinished work on the right side of the design.

p. 16 (bottom). Near Moab, Utah. A petroglyph made by scratching shallow lines through the thin layer of rock varnish, revealing the light-colored sandstone below. The earring, headband, and hair-knot are characteristic of Apache and Navajo men of the last two centuries.

p. 17 (top). Bandelier National Monument, New Mexico. A petroglyph made by abrasion—by scratching or scraping deep gouges in the soft tuff (welded ash) rock.

p. 17 (bottom). Sand Island Petroglyph Site, Utah. Three small quadrupeds made by a combination of percussion and abrasion.

p. 18. Central Utah. Archaic Style pictographs with red, ochre, and black paint made high on the ceiling of a light-colored rock shelter. The white outlines on some of the figures are the remains of chalk applied during an earlier effort at recording.

p. 19. Hueco Tanks State Historical Park, Texas. A Jornada Style pictograph of a mask-like or face-like design, made with red and yellow paint on a light-colored rock surface.

p. 20. Central Utah. Rock-art made by a combination of abrasion and painting. The outline of the quadruped was ground into the rock, creating a shallow band of smoothed rock. Paint was subsequently applied to smoothed and unsmoothed areas.

p. 24. Coso Range, California. The petroglyphs on this rock are superimposed and have different amounts of rock varnish, indicating that the rock was used on several different occasions. The largest sheep measures nearly eight feet from nose to rump.

p. 27. Coso Range, California. Pecked petroglyphs nearly cover the surface of this basalt rock in the Little Petroglyph Canyon. Other adjacent rocks have no marks whatsoever.

p. 29. Three Rivers State Park, New Mexico. Some rock art uses the natural shape of the rock as part of the design, such as the "brow ridge" formed by the edge of this boulder.

p. 30. Fremont Indian State Park, Utah. Some rock art designs incorporate natural irregularities in the rock. This petroglyph was created around a deep natural pit in the rock surface.

p. 31. Three Rivers State Park, New Mexico. The maker of this petro-
glyph utilized the edge of the boulder to create half of a face.

p. 32. Three Rivers State Park, New Mexico. Human footprints and
handprints, and bird and animal tracks, are common in
Southwestern rock-art. These footprints are on a vertical sur-
face.

p. 33. Coso Range, California. The large mountain sheep figures
made on these separate rocks may have been made at the
same time.

p. 35. Three Rivers State Park, New Mexico. In many Southwestern
locales, petroglyphs have been made on prominent rocks in
the landscape. This rock overlooks a wide valley below.

p. 38. Coso Range, California. The petroglyphs on this rock were
made on different occasions over hundreds—perhaps thou-
sands—of years. It is apparent that some of the designs were
made at the same time.

p. 40. Three Rivers State Park, New Mexico. This design may repre-
sent a Mesoamerican deity known as Tlaloc.

p. 42. Central Utah. Barrier Canyon Style pictographs in red and
black paint on a massive rock face in central Utah include
wide-shouldered forms with "empty" eyes, wavy lines, and
other enigmatic details.

p. 44. Hueco Tanks State Historical Park, Texas. This face-like or
mask-like design was made using red- and turquoise-colored
paints on a light-colored rock surface.

p. 46. Northern Arizona. This Anasazi petroglyph panel includes
many connected elements.

p. 47. Central Utah. Archaic Style rock-art often includes series of
dots, lines, chevrons, and other non-figurative elements.

p. 48. (top). Coso Range, California. Petroglyphs that are primarily
non-figurative are often classified as Archaic Style.

p. 48. (bottom). Central Utah. Large, elongated painted figures with
broad shoulders are the most distinguishing characteristics of
the Barrier Canyon Style.

p. 50. Coso Range, Little Petroglyph Canyon, California.

p. 51. Fremont Indian State Park, Utah. A Fremont Style petroglyph.

p. 52. Three Rivers State Park, New Mexico. Jornada Style petroglyph.

p. 53. Deer Valley Rock Art Center, Arizona. Patayan Style petroglyph.

p. 54. V-Bar-V Petroglyph Site, Arizona. A number of these Sinagua Style petroglyphs have small cupules in their centers.

p. 56. Central Utah. These petroglyphs are unusually detailed and delicate.

p. 58. Nine Mile Canyon, Utah. The presence of horses in petroglyphs serves as an important dating tool.

p. 64. Central Utah. This Fremont Style panel in Central Utah is particularly complex and defies easy interpretation. It is a detail of the panel shown on page 146.

p. 65. Three Rivers State Park, New Mexico. Stylized figures that resemble insects or mammals may be indicative of the actual creatures depicted, or of symbolic associations.

p. 66. Central Utah. Figures obviously made in relation to one another often suggest a narrative or story.

p. 67. Nine Mile Canyon, Utah. This complex panel includes horizontal grids that have been described as both nets and snakes. Perhaps they represent both?

p. 68. Coso Range, California.

p. 69. Nine Mile Canyon, Utah.

p. 70. Fremont Indian State Park, Utah. This figure has been described as a calendar.

p. 71. Three Rivers State Park, New Mexico. Crescents and quartered circles are often seen as suggestive of celestial phenomena.

p. 72. Coso Range, California. Many oval or rectangular petroglyphs with complex internal designs are found in the Coso Range. They have been interpreted as representing individuals or groups.

p. 73. (top). Three Rivers State Park, New Mexico.

p. 73. (bottom). Coso Range, California. Patterned dots, concentric circles, and radiating lines are suggestive of an altered state of consciousness.

p. 74. Colorado River Rock-Art Sites, Utah.

p. 75. Coso Range, California. Two associated figures of dramatically different sizes are sometimes interpreted as a human and a spirit helper.

p. 77. Coso Range, California.

p. 78. Near Moab, Utah. Fremont Style anthropomorph with the characteristic trapezoidal body.

p. 80. Three Rivers State Park, New Mexico.

p. 83. Nine Mile Canyon, Utah. This enigmatic figure has anthropomorphic qualities.

p. 84. Central Utah.

p. 85. Coso Range, California.

p. 86. Central Utah. This site had been a popular party spot and was heavily vandalized. It was restored in an extensive conservation effort.

p. 88. Three Rivers State Park, New Mexico.

p. 90. Three Rivers State Park, New Mexico.

p. 91. Three Rivers State Park, New Mexico.

p. 93. West-Central Utah.

p. 95. Three Rivers State Park, New Mexico.

p. 97. West-Central Utah.

p. 98. V-Bar-V Petroglyph Site, Arizona. Note how some of the elements are linked to a natural horizontal crack in the cliff face.

p. 102. Three Rivers State Park, New Mexico.

p. 104. Hueco Tanks State Historical Park, Texas. These pictographs had been severely disfigured by spray painted graffiti. The paint was removed by a rock-art conservator.

p. 106. Newspaper Rock State Historical Monument, Utah.

p. 108. Central Utah.

p. 142. Coso Range, California.

p. 144. Coso Range, California.

p. 146. Central Utah. This is one of the most complex petroglyph panels in the Southwest.

p. 148. Hedgpeth Hills Petroglyph Site at the Deer Valley Rock Art Center, Arizona.

p. 150. Coso Range, California.

p. 152. Three Rivers State Park, New Mexico.

p. 154. Colorado River Rock-Art Sites, Utah. The large bear was added over the scene that includes the quadrupeds and anthropomorphs. It has been damaged by bullets.

p. 168. Three Rivers State Park, New Mexico.

Index

Abrasion technique 16–17
 illustrations 16, 17, 20
Access restrictions to rock-art sites 85,
 86, 94, 111, 122, 133
Agoyo, Herman 105–106
Agriculture and rock-art 43, 49, 51,
 71, 76
All-American Man pictograph 134
Altered states of consciousness 74–75
 illustration 73 (bottom)
American Indian Rock Art (journal)
 143
American Indians (*see* Native
 Americans and *names of individual
 tribes and communities*)
American Rock Art Research
 Association 143, 147, 151
AMS radiocarbon dating 62
Anasazi Style rock-art 45, 52, 126,
 140–41
 illustration 46
*Ancient Hebrew Inscription in New
 Mexico* (Web site) 151
Andrée, Richard 8
Anthropomorph, definition of 46
 illustrations 17 (top), 29, 30, 51,
 53, 78, 85
Antiquities Act 100–101
Anza-Borrego Desert State Park 120
Apaches 116–17, 132–33
ARARA 143, 147, 151
Archaeological Resources Protection
 Act 99, 100–101
Archaeology and rock-art research 3,
 34, 57, 58–59, 63, 76–77, 89, 94
Archaic Style rock-art 44, 47, 48, 49,
 65, 114, 116, 117, 132–34, 136
 illustrations 18, 47, 48 (top)
Arizona State University 114, 147–48

ARPA 99, 100–101
Atlatl Rock site 126–27
Audio effects at rock-art sites 10, 11,
 32, 37

Bandelier National Monument
 127–28
 illustration 17 (top)
Bancroft Library 147
BARARA 143, 147
Barrier Canyon Style rock-art 48–49,
 134–35, 136
 illustrations 14, 42, 48 (bottom)
Basketmaker Style rock-art 49, 126,
 140–41
Bay Area Rock Art Archive 147
Bay Area Rock Art News (newsletter)
 143
Bay Area Rock Art Research
 Association 143, 147
Blythe Intaglios 121
Box Canyon petroglyphs 117–18
Bureau of Land Management 85, 99,
 100, 116, 136
Butler Wash Petroglyph Site 140–41

Calendars in rock-art 70–72, 137
 illustration 70
Callahan, Kevin L. 152
Campbell, John F. 152
Canyonlands National Park 134–35
 Great Gallery 134–35
 Horseshoe Canyon 134–35
 Maze District 134–35
 Needles District 134–35
Capitol Reef National Park 135–36
Carbon-14 dating 61, 62

Castings and impressions of rock-art
 82, 91
Cation-ratio dating 26, 61
Cave paintings 9
Caves and shelters used for rock-art
 36, 113, 121–22, 133
Celtics, as rock-art makers 44
Chaco Canyon 45, 59, 128–29
Chaco Culture National Historic Park
 128–29
Chalking to highlight rock-art 90
Charcoal used in rock-art 10, 19, 21,
 62, 116–17, 122
Chippindale, Christopher 8
Christian symbols in rock-art 43
Chumash Painted Cave State Historic
 Park 121–22
Clan symbols and marks 36, 72–73
Cleaning rock-art 82, 90, 91, 98
Clear Creek Canyon 137–38
Cliff paintings 9
Cochiti Pueblo 128
Coconino National Forest 85, 119
Colorado River rock-art sites 136–37
 illustrations 74, 154
Colors used in rock-art 10, 18–22
Coming-of-age ceremonies 43, 74, 76
Conservation and Protection Network
 (Web site) 151
Conservation of rock-art viii, 1–2, 25,
 26, 81–104, 151
 damage-prevention viii, 81, 82, 83,
 86–95, 111
 impacts from visitors 26, 37, 81,
 82, 111
 impacts from weathering 10, 18,
 19, 26, 31, 36, 82
 professional conservators 90, 91,
 98, 103, 151
 vandalism 1, 26, 37, 81
Coso Range Style rock-art 49–50,
 122–23
 illustrations 24, 27, 33, 38, 50,
 142, 144, 150
CR dating 26, 61
Crosby, Harry 150
Cross-quarter points 71

Cupules 11, 31, 119
 illustration 54
Curvilinear, definition of 46

Dating rock-art 3, 26, 45, 57–62, 90
 and archaeology 3, 57, 58–59
 methods 1, 3, 26, 57–62
 problems 3, 57, 90
Deciphering or translating rock-art 1,
 34, 63–65, 67
Deer Valley Rock Art Center 114, 143,
 147–48
 illustrations 53, 148
Desert Classic Trail petroglyphs 118
Desert varnish 25–26
Diegueño people 120
Dint, definition of 15
Documentation of rock-art sites 1–2,
 34, 77, 81, 90, 91, 111, 143–46
Dogs at rock-art sites 86, 87, 89, 94
Doodles, as an interpretation of rock-
 art 41
Dust on rock-art 82, 91
DVRAC 114, 143, 147–48
 illustrations 53, 148

East-facing rock-art sites 32, 33, 36
Echoes at rock-art sites 11, 32, 37
Edberg, Bob 148, 152
El Morro National Monument 130
Equinox 71
European-Americans, as rock-art
 makers 43–44, 130

Fate Bell Shelter 134
Figurative, definition of 46
Fires near rock-art 94
Fountain, John 153
Four Corners region 45, 49
Fremont Indian State Park 137–38
 illustrations 30, 51, 70
Fremont Style rock-art 51, 135,
 137–38, 139–40
 illustration 78
Friends of Sierra Rock Art 144

Frijoles Canyon 127–28
FSRA 144

Gebhard, David 150
Geoglyph 10, 22–23, 81, 121
 definition of 10, 22
 origin of word 10
 techniques 10, 22–23
Geometric, definition of 46
 illustrations 6, 16 (top), 91
Gila River Indian Community 52
Gila Style rock-art 52, 114, 116, 118
Glyphs 8
Graffiti, as an interpretation of
 rock-art 41
Graffiti on rock-art 81, 91, 98
Grapevine Canyon 125
Gravel geoglyphs 10, 23
Grid, definition of 46
Grinding slicks 10, 31
Grinding technique 16–17

Habitations near rock-art sites 32, 33,
 34, 45, 73
Halley's Comet 129
Havasupais 53
Hedgpeth Hills Petroglyph Site 114,
 147–48
 illustrations 53, 148
Heizer, Robert F. 150
Heyser, Doak 154
Hidden areas used for rock-art 32, 36
Hispanic rock-art 130
Historic events in rock-art 59, 66
Hohokam Style rock-art 52, 114, 116,
 118
Holbert Trail petroglyphs 118
Homolovi Ruins State Park 115
Hopis 52, 54, 70, 72, 73, 115
Hualapais 53
Hueco Tanks State Historical Park
 132
 illustrations 19, 44, 104
Hunting areas near rock-art sites 35,
 67–69

Hunting magic, as an interpretation
 of rock-art 35, 43, 51, 67–69

IFRAO 144–45
Indian hieroglyphics 8
Indian signs 8
Indians (see Native Americans and
 names of individual tribes and com-
 munities)
Initiation ceremonies 43, 74, 76
Intaglios 10, 22, 23, 25, 121
International Federation of Rock Art
 Organizations 144–45
International Rock Art Congress 144
Interpretations of rock-art 1, 34, 41,
 63–77, 93
IRAC 144

Jornada Mogollon Style rock-art
 52–53, 131, 132–33
 illustrations vii, 19, 44, 52, 104

Kane Creek Blvd. sites 136–37
Kumeyaay people 120

La Pintura (newsletter) 143
Ladder, definition of 46, 65
 illustration 18
Lichen on rock-art 26, 60–61, 82, 91,
 96
Lichenometry 60–61
Links to Rock Art Sites (Web site) 152
Links to the Past (Web site) 101
Little Colorado River 115
Little Petroglyph Canyon 122–23
Locations of rock-art 7, 28, 29–37, 41
 audio effects 10, 11, 32, 37
 caves and shelters 36, 113, 121–22,
 133
 east-facing 32, 36
 habitation areas nearby 32, 33, 34,
 45, 73
 hidden areas 32, 36
 hunting areas 35, 67–69
 previous rock-art nearby 19, 30,

33, 36, 37, 59, 60, 89
prominent areas 32, 36
property nearby 36, 72
resources nearby 32, 33, 36
sacred areas 34, 41
trails nearby 33, 36, 72
water sources nearby 32, 33, 34, 69
Los Lunas decalogue stone 44, 151, 153
Lost City Museum of Archaeology 127

Mallery, Garrick 1, 64
Marcos de Niza Rock 117–18
Marymor, M. Leigh 147, 151
Maturango Museum 122–23
McCulloch, J. Huston 153
Megafauna, definition of 46
Men, as rock-art makers 13, 43
Mesa Verde 45
Mesa Verde National Park 124
Minerals used in rock-art 10, 19–22
Moab, Utah, rock-art sites 136–37
 illustrations 16 (bottom), 78, 154
Mohaves 121
Moss on rock-art 91, 96
Mouse Tank Site 126–27
Mythology 66

National Outdoor Leadership School 85
National Park Service 85, 101
National Pictographic Society 145
National Pictographic Society Newsletter (newsletter) 145
Native Americans (*see also names of individual tribes and communities*)
 interpreting or explaining rock-art 2, 20, 34, 41, 53–54, 58, 63, 66, 77, 87 105–107
 oral history and traditions 2, 53–54, 58, 87
 as rock-art makers vii, 2, 7, 13, 43–44
 rock-art preservation concerns 87, 105–107

Navajos 59, 66, 72
Newspaper Rock State Historical Monument (Utah) 138–39
 illustrations frontispiece, 106
Nine Mile Canyon rock-art 139–40
 illustrations 58, 67, 69, 83
Non-figurative, definition of 47
NPS (*see* National Park Service *or* National Pictographic Society)

Offerings and rituals at rock-art sites 86
Ogam speakers, as rock-art makers 44

Painted Rocks Petroglyph Site 116
Paints used in rock-art 18–22, 62
 application 19
 composition 19–22, 62
Paiutes 48
Palatki 116–17
Paleo-Hebrew speakers, as rock-art makers 44
Panel, definition of 47
Panther Cave 133
Patayan Style rock-art 53, 114
 illustration 53
Patina (*see* Rock varnish)
Pecking technique 12, 15–16, 20
Peñasco Blanco 128–29
Percussion technique 14, 15–16, 20
 direct 15
 indirect 12, 15
Petroforms 10, 23
Petroglyph
 definition of 8
 origin of word 8
 synonyms 8
 techniques 8–9, 13, 14–17, 25
Petroglyph National Monument 105–107, 130–31
Petroglyph Point Trail (Colorado) 124
Petroglyph Pullout Trail (Utah) 135
Petroglyphs and Rock Paintings (Web site) 152
Photography of rock-art 82, 95–97

Pictograph
 definition of 9
 origin of word 9
 synonyms 9
 techniques 9–10, 13, 55
Picture rocks 8, 9
Picture writing 8
Picture-Writing of the American Indians
 (book) 1
Piedra Pintada Books 148, 152
Pigments used in rock-art 18–22, 62
Pilles, Peter 119
Pima Canyon petroglyphs 117–18
Pintura, La (newsletter) 143
Pipette, definition of 47
Potash Road Sites 136–37
Presa Canyon 133
Preservation of rock-art (*see*
 Conservation of rock-art *and* Visitor
 guidelines for rock-art sites)
Prominent areas used for rock-art
 sites 32, 36
Protection of rock-art (*see*
 Conservation of rock-art *and* Visitor
 guidelines for rock-art sites)
Pueblo Grande Museum 118
Pueblo peoples 45, 53–54, 105–106

Quadruped, definition of 47
 illustrations 8, 17 (bottom), 20,
 56, 90, 108
Quechans 121

Radiocarbon dating 61, 62
Rake, definition of 47, 65
Recording of rock-art sites 1–2, 34,
 77, 81, 90, 91, 111, 143–46
Red Rock Canyon National
 Conservation Area 126
Reworked rock-art designs 30, 37, 89
Rice University 152
Rio Grande Style rock-art 53–54,
 127–28, 130–31
Rock alignments 10, 23
Rock-art
 as art 7–8, 28, 30
 definition of 7

Rock Art at Rice (Web site) 152
Rock Art Foundation, Inc. 148
Rock Art Glossary (Web site) 152
Rock-Art Listserv (Internet distribu-
 tion list) 149
RockArtNet (Web site) 153
Rock Art of the Southwest (Web site)
 153
Rock-art research 1–4, 13, 76–77, 82,
 143–50
 history of 1
 future directions 3, 4, 76–77, 82
Rock Art Research (journal) 144
*Rock Art Solar Markers; the SOLMAR
 project* (Web site) 153
"Rock Art Studies: A Bibliographic
 Database" 147
Rock carvings 8
Rock drawings 8
Rock engravings 8
Rock etchings 8
Rock paintings 9
Rock shapes or natural features incor-
 porated in rock-art 30
 illustrations 29, 30, 31, 35, 71, 77,
 98
Rock types used for rock-art 8–9, 10,
 17, 18, 27–28, 30
Rock varnish 8, 14, 25–26, 28,
 59–60, 61
 composition 25, 26
 dating 26, 59–60, 61,
 origin 25–26
 relative darkness 26, 59–60
Rock writing, as an interpretation of
 rock-art 1, 34, 63–65
Rubbings of rock-art 82, 91

Sacred areas and rock-art 34, 41
Sacred sites 34, 41, 86, 87, 88, 105
Sacred Sites International Foundation
 85
Salt River Pima–Maricopa
 Community 52
San Ildefonso Pueblo 128
San Juan River 45, 49, 140–41

Sand Island Petroglyph Site 140–41
 illustration 17 (bottom)
Santa Clara Pueblo 128
Scraping technique 16–17
Seminole Canyon State Historical
 Park 133–34
Settings (see Locations of rock-art)
Shamanism and rock-art 63, 73–76,
 123, 133–34
 illustrations 27, 74, 75, 142
Shapes of rocks and rock-art (see
 Rock shapes or natural features
 incorporated in rock-art)
Shoshones 48
Sighting from rock-art sites 11, 33, 36
Sign language, as an interpretation of
 rock-art 64–65
Signs, as an interpretation of rock-art
 1, 34
Sinagua Style rock-art 54–55, 119
 illustrations 54, 98
Site etiquette 85–95, 97
Site recording 1–2, 34, 77, 81, 90, 91,
 111, 143–46
Sky-watching rock-art sites 11, 36, 59,
 63, 70–72, 153
 illustration 71
Smoke near rock-art 94
Smudging at rock-art sites 94
SNRAE 145–45
SOLMAR Project 153
Solstice 71
Some Archaeological Outliers (Web
 site) 153
Sonin, Bill 147
Sound effects at rock-art sites 10, 11,
 32, 37
South Mountain Park 117
Southern Nevada Rock Art
 Enthusiasts 145–46
Southwestern United States Rock Art
 Gallery (Web site) 154
Souvenirs from rock-art sites 89
Spanish Colonial inscriptions 43–44,
 130
Spark-producing rocks at rock-art
 sites 11

Spirit Mountain 125
Star charts at rock-art sites 72
Styles of rock-art 1, 45–55, 57, 59, 60
 and dating 1, 57, 59
 identification of 1, 45–55
Superimposed rock-art designs 19,
 30, 37, 59, 60, 89
 illustrations 6, 24, 27, 33, 38, 150,
 154
Supernovas 59, 72, 129
Sympathetic magic, as an interpreta-
 tion of rock-art 68–69

Tabor, James D. 151
Taçon, Paul S. C. 8
Three Rivers State Park 131
 illustrations vii, 2, 4, 6, 8, 12, 13,
 16 (top), 29, 31, 32, 35, 40, 52,
 65, 71, 73, 80, 88, 90, 91, 95, 102,
 152, 158
Tlaloc 52, 53
 illustration 40
Tohono O'odham Nation 52
Tools for rock-art making 15–20,
 22–23
Touching rock-art 82, 91, 92
Tracce (online bulletin) 153
Tracings of rock-art 91
Tracks (online bulletin) 153
Trails near rock-art sites 33, 36, 72
Trances 73–76
Translating or deciphering rock-art 1,
 34, 63–65, 67
Tsankawi Pueblo 128
Tyuonyi Pueblo 128

UCLA Rock Art Archive 149–50
URARA 146
U.S. Naval Air Weapons Station 123
Utah Rock Art (journal) 146
Utah Rock Art Research Association
 85, 146
Utes 48, 138

Valley of Fire State Park 126